Lost Restaurants
of
WALLA WALLA

CATIE MCINTYRE WALKER

AMERICAN PALATE

Published by American Palate
A Division of The History Press
Charleston, SC
www.historypress.com

Front cover, top left: photo by Jean Cline, 1984, courtesy of Joe Drazan, the Bygone Walla Walla Project; *top center*: courtesy of Joe Drazan, the Bygone Walla Walla Project; *top right*: courtesy of Beverly Cunnington; *bottom*: courtesy of Joe Drazan, the Bygone Walla Walla Project.
Back cover: courtesy of Joe Drazan, the Bygone Walla Walla Project; *left inset*: courtesy of Joe Drazan, the Bygone Walla Walla Project; *right inset*: courtesy of Joe Drazan, the Bygone Walla Walla Project.

First published 2018

Manufactured in the United States

ISBN 9781467136341

Library of Congress Control Number: 2018940072

Notice: The information in this book is true and complete to the best of our knowledge. It is offered without guarantee on the part of the author or The History Press. The author and The History Press disclaim all liability in connection with the use of this book.

This journey is dedicated to Dad, who introduced his children to fine dining, lunch counters, old highway diners and hamburger drive-ins with carhops. It was also in an old Walla Walla diner on Main Street where he first laid eyes on Mom and gave her one of his classic winks.

Contents

Acknowledgements

In the world of professional writing, there is one lesson I have learned: writing fiction is a lot easier than writing about history. With fiction, the writer can be fanciful with no rules, and the words come as easy as making up a bedtime story for a little one. With regard to writing about history, a lot of research comes with it—in fact, more hours are spent on research than on the actual writing. Sometimes, we even find snippets of history that contradict each other. I suppose that in those cases, the author has to make a choice and use the information that makes the most sense to her.

Therefore, I owe a lot of gratitude to those historians, journalists and collectors who came before me and provided me with access to significant dates, information and photos.

Gratitude also goes to my mother, siblings and uncle, who recently related restaurant stories and information and even jogged my memory about the times we dressed to dine at local or out-of-town restaurants or wore summer casuals while relaxing in the car parked at the local drive-in, sipping a root beer float. Dining out with the family was treated very much like going on a field trip to monuments and museums or picnicking by the river hunting agates—so, yes, our family also had field trips to restaurants. And like a field trip, when visiting a restaurant, we often left with some new information, whether it was about the owner or the food, and we also learned about manners.

The Lost Restaurants series is a wonderful collection of books mostly about larger cities' former and memorable eateries. So I became excited

while visiting on the phone with Christen Thompson, former senior acquisitions editor at The History Press, when she suggested that, while I was researching information about another book we were discussing, I also look to the future and possibly make Walla Walla a part of the Lost Restaurants series. Christen was aware of the recent accolades Walla Walla was receiving for its wine and food scene. I owe Christen many thanks for the knowledge about the series of Lost Restaurants books and, most of all, for the inspiration.

Many thanks to Artie Crisp, senior acquisitions editor at The History Press, who took over the job of checking in on me, trying to keep me on some kind of a path, exercising patience, allowing me to change the course and put my "farm to table" book on the slow-simmering back burner to pursue the Lost Restaurants idea. Also, a big thank-you to Rick Delaney, editor at The History Press, for making me look good and for making the worst part of publishing as easy as possible.

When it comes to local history projects, the first person I always think of is Joe Drazan of the Bygone Walla Walla Project website. Joe, a retired librarian from Penrose Library at Whitman College, recently gave me a tour of the college's archives. Thank you to Joe for his photo research, for a CD collection of great photos he prepared for me and for his enthusiasm about this book project.

There are many other people without whom I could not have accomplished what I visualized for this book. To Alasdair Stewart, managing editor/operations of the *Walla Walla Union-Bulletin*, thank you for allowing me to "dig" through the archives. To my cousin Deana McCubbins Lechner, who in her youth stirred up a "few" gallons of "special sauce," thank you for sharing some secret ingredients. Many thanks to Jim German and Samantha Shelton of Passatempo Taverna, former home of the Pastime Café, for their hospitality. To Dee Cusick for her photographic talent and patience when it came to the *model* she had to work with. To journalist Steven P. Bjerklie, with love and appreciation for being my biggest supporter and writing muse. An acknowledgement to good friend and former local radio personality "John Hammond" for sharing his memories about one very cold evening.

Here's to many other contributors who shared their photographs, stories and recipes—you will see their names throughout the book. Thank you.

Introduction

Walla Walla—the town they liked so well, they named it twice.
—Al Jolson

It's personal. Food is personal. There are restaurants in our lives that hold the memories of our favorite meals and experiences. When a restaurant leaves the community and becomes "lost," its shingle may no longer hang from the storefront, but the memories are never lost.

How many of us at one time or another said to friends or family members after dining on a specialty from their home kitchen, "This is so delicious, you ought to open a restaurant"?

Those who have entered into this world of being a restaurateur know only too well that owning a restaurant is about dedication. There are rarely days off—if you want to succeed. It's about the survival of the fittest. It's about the owner changing one little thing on a plate to make that sandwich or entrée even fresher and tastier; and sometimes, that change may have ruined a customer's memory of it—because it's personal. The owner may have changed the worn and soiled old wallpaper in the dining room after a thirty-five-year run, and this may have ruined a customer's nostalgic moment—because it's personal. We tend to take it personal when a restaurant changes owners or even shutters, and without thinking we become a bit indignant that it doesn't remain open for business despite the fact that the owner or cook eventually wants to retire or, even worse, unexpectedly dies.

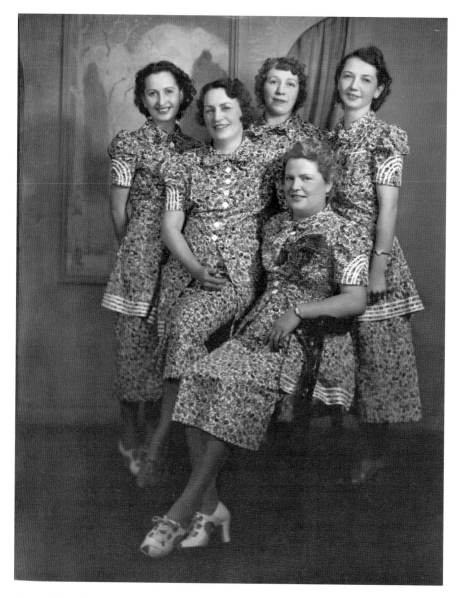

At the Villa with Maxine Harding (*seated*) and Edna, Carrie, Rose and Mollie. *Courtesy of Beverly Cunnington.*

A succeeding generation doesn't always have the same goal as did its parents or grandparents to spend all of their lives dedicated to the kitchen. Sometimes it's even worse for us when a favorite restaurant closes and a new one with new ownership opens in the familiar space. "Why isn't the

new place serving mama's special red sauce that the former place used to make? It's not the way it used to be." Sometimes the new establishment is an improved version of the old place, but it is still a source of conflict in our memories.

There was a time when one of Walla Walla's claims to fame was the 1953 Warner Bros. cartoon in which Daffy Duck portrays a persistent door-to-door salesman for the fictional "Little Giant Vacuum Cleaner Company of Walla Walla, Washington." Say that three times.

Today, Walla Walla, Washington, has come a long way from the days of being spoofed by cartoon characters. The Lost Restaurants series, part of the American Palate brand, features the history of dining from some of the largest cities on the U.S. map, including Denver, Detroit, Louisville, Tucson, Sacramento and Seattle—and now Walla Walla. Certainly, Walla Walla isn't a booming metropolis, but it does have a rich history of dining from the time the town was built in the 1860s to today.

A term I often use to describe Walla Walla's history and to bring it around to the twenty-first century is that it has come "full circle." In the early days, Walla Walla—one of the oldest cities in the state of Washington—grew its population and wealth from tourism. Miners of the gold rush in nearby Idaho arrived, and a strong agricultural industry came about due to the long growing days and the rich soil. Many of us who were born and raised in Walla Walla, especially those from the "boomer" generation, remember it for its fine dining, downtown diners and drive-ins.

In the mid-1970s and 1980s, a few commercial indoor malls settled into town, leaving downtown Walla Walla's vacancy rate at almost 30 percent. The beautiful old downtown architecture remained, but many of the buildings were covered with faded store façades of the 1950s and 1960s; even the pride of Walla Walla, the historic Marcus Whitman Hotel, had declined. Many locals proclaimed that they wanted Walla Walla back to the way it "used to be." However, no one ever really specified the decade they wanted Walla Walla to return to, as the town had seen many decades.

Visitors to the city would later describe downtown Walla Walla by creating a scene of a western ghost town with one dried, lone tumbleweed traveling down a dusty Main Street.

The year 1984 brought the start of progress, as the Walla Walla Main Street Foundation (eventually renamed the Downtown Foundation) was formed by concerned businesses and property owners. In the same year, the Walla Walla Valley was officially designated by the Alcohol and Tobacco Tax and Trade Bureau (TTB) of the U.S. Department of the Treasury

an American Viticultural Area (AVA) due to the growth of wineries and vineyards. Today, there are close to three thousand acres of prime vineyards and more than one hundred bonded wineries.

In 1999, the Marcus Whitman Hotel was restored to its classic elegance and detail. It officially reopened in 2001, along with premier dining, wine tastings, conference rooms and rooftop gardens.

Today, the Walla Walla Valley is receiving numerous national awards and accolades for its wine, for being one of the friendliest towns, for its historic trees and parks, as one of the top places to retire, as best college town, prettiest winter town and a top travel destination. Most of all, Walla Walla is receiving recognition for its food culture, as seen in the *New York Times*, *Wine Enthusiast*, *Fodor's*, *Seattle Times* and *Rand McNally Education Publishing Co.*, to name a few publications.

The "town they liked so well, they named it twice" has come full circle with a vibrant downtown featuring historic buildings filled with specialty shops, fine clothing boutiques, a live theater, several music venues, spas, galleries, a confectioner's shop, wine-tasting rooms, bakeries, restaurants, cafés, sports bars and coffee shops. Downtown also hosts a seasonal farmers market and annual street festivals featuring local agriculture and tasty fare. There's also a popular monthly food truck night at the Walla Walla Regional Airport near the Port of Walla Walla's Winery Incubator project. Even the Port of Walla Walla area, a former U.S. Air Force base, is now filled with wineries, microbreweries, distilleries, a coffee roaster and a bakery.

It's perfectly normal in Walla Walla to dine inside a gas station indulging on beef brisket piled high on a fresh-baked in-house bun, with the second course being a Middle Eastern–style falafel and a side of savory and cheesy Canadian-style poutine. Most important, the same brisket that was cooked long and slow came from a smoker tucked away behind the gas station. If you smell green chiles being roasted as you're running errands on Main Street, you're not imagining it. Hatch chiles are being roasted over an open flame behind one of the popular downtown breakfast spots. You've heard of wine tasting? How about olive oil and vinegar tastings? There's a shop on Main Street featuring premium olive oil and vinegar tastings with several to choose from. Who creates a fire using vineyard cuttings or old purple-tinged wine barrel staves for roasting marshmallows or for smoking Columbia River sturgeon? There are even wine-tasting dinner parties being thrown in the downtown alleys. Food is all around Washington State's most prominent wine town, Walla Walla.

Hungry for authentic tacos? There's a cure for that on almost every block. Best of all, many of the taco trucks feature the Walla Walla Taco—carne asada covered with the popular grilled Walla Walla Sweet Onions and topped with fresh chimichurri sauce. On the side of the highway, there's a team of four-legged, long-tailed and maned "horse power" plowing gardens and vineyards. Welcome to Walla Walla.

It is in this decade—in fact, it is in this new century—that Walla Walla is back to the way it "used to be."

As I write this account of the lost restaurants of Walla Walla, I can't help but think back to my own family memories of local restaurants. Forty to fifty years ago, we didn't go out to eat as often as families do today. Growing up, my family didn't go out to eat unless it was a special occasion or sometimes even payday for the parents. There was no kale or quinoa on the menu, nor did we have choices of gluten-free bread or a vegan omelet. Organic? Grass-fed? You mean there are other types of vegetables and meat other than organic and grass-fed? What is this fancy new word, *organic*? Raised in the Walla Walla Valley, we thought everyone made their own compost for their gardens and hoed or plucked weeds by hand.

We dined out more for the experience and on special occasions, to be with family and friends, and less from necessity. We often dressed in our Sunday best, and there was no need for signs that read "No shoes. No shirts. No service." We visited across the table, and there were no devices or distractions. We didn't take photos of our food. Maybe the only phone to be heard came from the restaurant's front desk or in the back of the kitchen, from staff taking reservations or a takeout order.

My dad loved going out to dine, no matter if it was local or when traveling out of town. Often on Friday afternoons, he would call Mom to "have the kids cleaned and dressed, and ready to go out" by the time he got home from work. Before we even left the house, my siblings and I were lined up, sitting on the white Naugahyde midcentury couch and were reminded of our manners and what was expected of us. Our parents didn't yell at us in a restaurant. Our parents didn't ignore us, either. If we even looked like we were going to misbehave, we simply got "the look"—the cold, hard stare of nonblinking pale blue parental eyes. Spank us, shackle us, scream at us, limit our food intake to one bowl of cold and lumpy porridge a day, take away our dessert for the rest of our lives or even send us away to an orphanage labor camp, but never give us "the look."

MY PERSONAL MEMORIES OF DINING in Walla Walla take me back to a waitress at one of the popular locally owned Italian restaurants. She often wore a pink uniform-style dress with a handkerchief pinned like a corsage above her left breast pocket. Her hair was kept tidy in a net, and she wore bright red lipstick. This waitress was a rebel with her vivid lipstick shade, choosing to color "outside the lines." As our favorite waitress stood at the table taking our orders or briskly walked through the dining room, she exuded an aromatic bouquet of cigarettes and stale Tabu eau de Cologne, a popular fragrance from the 1930s to the 1960s. As odd as this may sound, it was a comforting scent, a familiar scent. As an adult, I continued to visit this restaurant, especially after Saturday evening Mass, and she was always there. Our favorite waitress looked the same as she did when I was a youngster, and I was indeed thankful for the nostalgia. She never disappointed me.

There are other memories about dining when I was a child, especially memories of sitting next to my dad at local lunch counters and drive-ins. I often copied whatever he ate. If he ordered a hot turkey sandwich at the lunch counter—an open-faced, white-bread sandwich piled with slices of turkey, a dome-like scoop of mashed potatoes in the center of the two diagonally cut wedges of bread and the whole plate smothered with savory gravy—then I would have the same. And, usually, what I didn't eat, Dad would finish for me.

Weekend summer evenings were often spent at the local drive-ins. People come out at night during the summer in Walla Walla. After a day of scorching temperatures, the sun goes down late, bringing to the valley a wonderful, fresh, cool breeze. Teenagers cruised Main Street or settled at one of the drive-ins for a late dinner or a second dinner. Sometimes, they grabbed an ice cream cone and then headed up to the foothills of the Blue Mountains and watched the "fairy lights" move back and forth across the hills. It was really combines up in the pea fields doing their seasonal harvest, but fairy lights seemed more romantic.

During those decades, drive-ins were open only during the warm spring, summer and early fall months. The limited schedule was no doubt due to the carhops being back in school and car heaters not being as dependable as they are now. I remember sitting in the back seat of the family car at one of Dad's favorite drive-ins. If Dad ordered the BBQ beef sandwich, then that's what I would order. An owner at one of the drive-ins gave me my own "baby" root beer mug. Today, it has a special place of honor in my kitchen.

For many of us, these former restaurants held special memories that made an impact on our lives. I remember attending my first junior high "sock

hop." It didn't dawn on me at the time, but of course my parents were concerned—I was no longer their little girl in grade school. The parental units knew there was even a chance I might have my first slow dance without them chaperoning, no doubt to the song "Cherish" by the Association. I remember that, after the dance, Dad picked me up and off we went for a "dinner date"—just the two of us, without the other siblings. This may have been my dad's only opportunity to hear firsthand, and rather disapprovingly, that I no longer thought boys had "cooties."

We went to the newest and "hippest" place, where they sold hamburgers by the length and the decor was right out of a *Jetsons* cartoon. From the sock hop to the spaceship setting, it was a very 1960s moment, one that you might see on the television series *The Wonder Years*.

In my later years, I accepted an engagement ring to be married over a turkey sandwich and macaroni salad at a popular downtown lunch counter. It was the place to see which businessman in town was drinking his lunch or watch the rotisserie chickens spin and roast as you passed by the diner's windows.

How many of us collected old decorative placemats, postcards and matchbooks for keepsakes from some of our favorite restaurants, especially those souvenirs that marked significant occasions?

DURING THIS JOURNEY OF THE *Lost Restaurants of Walla Walla*, you may wonder what the deciding factor was in acknowledging certain restaurants. There have been literally hundreds of dining establishments in the valley's 157 years of history. To list all of them, and to chronicle them with 100 percent accuracy, would be a difficult and daunting task. In fact, it is impossible. Therefore, I chose "lost" restaurants with accessible information. I sought dates, reproducible photos and newspaper clippings from library and newspaper archives and even old Walla Walla city directories. During my research, I discovered names of restaurants with no accompanying information about them other than perhaps an address. To some of those, I at least give a mention.

Several chain restaurants that left Walla Walla are not included here, as their franchises are still in existence. However, I did list a couple of favorite chains, as many peers have cited these franchises with great memories. I also chose specific timelines, such as listing only those lost restaurants that opened before the twenty-first century. Restaurants that opened and became lost in the new century were omitted. In my research, I also discovered

many lost confectioners, bakeries and ice cream shops—and even popular taverns. Those lost names alone could fill up their own book. Perhaps all of those bakeries, sweetshops, taverns and other restaurants will be in another book—"Part Two."

As I DISCOVERED ONE RESTAURANT, I would often come upon another, and another, and another…leading me to think that some locations in Walla Walla were either very conducive to a profitable restaurant or not at all.

There were former addresses that made it somewhat challenging to nail down a restaurant's location. Many addresses changed. Even now, for a current structure, the address has been changed from a simple one on Main Street that didn't include "East," "West," "North" or "South." Many addresses as per Google have led to nothing but a photo of a parking lot or a new structure where an old building used to be. Of course, phone numbers changed from three digits to seven digits with Ja5 or Ja9 (Jackson) preceding, to now excluding letters and written only as numerals.

There seemed to be themes in dining trends. In the 1890s, there were several places on Main Street in Walla Walla that sold oysters and advertised them to accompany the cigars and whiskeys the shop owner also sold. The "Olympia Cocktail" was rather popular on hotel menus. It was an oyster appetizer featuring the native Olympia oyster, named after the state's capital and typically found in the Puget Sound area. In the 1930s and '40s, many hotels and fine-dining establishments listed "snowflake" potatoes on their menus. I conducted further research to find out more about these potatoes. A lot of coffee was served in the 1930s, with diner ads boasting coffee made in Silex (now Proctor Silex) coffee dispensers and machines. The Silex coffee rep struck gold when he walked the streets of Walla Walla. In the 1950s, many restaurants advertised "broiled" food, including chicken, steaks and even sandwiches. Once again, it made me wonder if a salesman had been in town for one day, hitting up all of the restaurants to buy his latest in kitchen technology known as the "Charcoal Broiler."

Another very noticeable theme for a few decades involved hotels and fountain lunch counters offering Thanksgiving dinner. The food listed on the menus was abundant—almost everything from "soup to nuts." With all of the Thanksgiving buffet menus, it left me wondering, "Didn't anyone in Walla Walla ever stay home for Thanksgiving?"

My research into these local restaurants, including advertising and local news articles, definitely was a reminder of U.S. history through

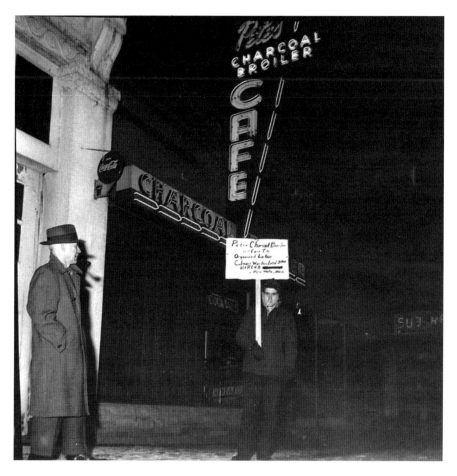

Labor Union pickets Pete's Alder Street Café, January 28, 1961. *Courtesy of Joe Drazan, the Bygone Walla Walla Project.*

the decades, including the hardships of immigrants and, later, restrictive laws that encumbered them even more. Walla Walla was no different than any small town or larger city in America. There were ads letting the public know of their "white cooks" or "lady cooks," and ads and signs reminding customers that their establishments were fine enough or safe enough for even "ladies and girls" to dine in. Newspaper ads mentioned taverns with signs on the doors reading "No Women Allowed," and even ads suggesting that a cigar and pool hall was the place to hide from the "little woman."

THIS BOOK PAYS TRIBUTE TO all of those fine old Walla Walla institutions. May this book inspire you to continue to support our locally owned restaurants today and in the future. It is a salute to the surviving dining establishments in Walla Walla that for fifty years and more went through the best of times and the worst of times with us, including Tommy's Dutch Lunch, Ice-Burg Drive-In, the Modern, Clarettes and Mr. Ed's.

Whether you dined or worked at one of these "lost" favorites, I hope this expedition back in time rekindles many warm memories and maybe even a few tears, as it did for me. This book will hopefully even unearth some new and interesting information about the history of Walla Walla. Perhaps it will inspire you to jot down a few of these former restaurant addresses and do some exploring on your own.

It's been a privilege for me to make these discoveries and share these stories with you. Thank you for taking the time to flip through these pages.

Here's to the many forgotten dishwashers and busboys, for without them…

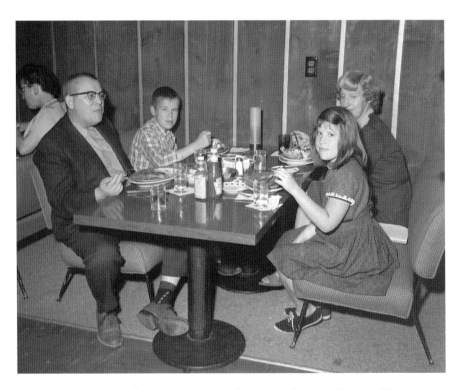

Anonymous Walla Walla family dining at a local restaurant in 1963. *Courtesy of Joe Drazan, the Bygone Walla Walla Project.*

1

The Place of Many Waters

Whiskey is for drinking; water is for fighting over.
—*Mark Twain*

There is a legend in Walla Walla that during its frontier days in the late 1800s, for every one church, there were four saloons—and Walla Walla has a lot of churches. In fact, during that time, Walla Walla had seven churches. You do the math.

Walla Walla was the largest town in Washington in the 1860s and '70s, and this once wild frontier was home to American Indians—the Cayuse, Nez Perce, Umatilla and Walla Walla tribes. Including the first settlers, the area would eventually flourish with the arrival of "tourism" of gold miners from the neighboring state of Idaho.

According to Northwest historian of the 1900s William Dennis Lyman, during the era of the gold rush, no social institution proved more prolific or more important than the saloon. In 1905, in the state of Washington, Everett, a suburb twenty-five miles north of Seattle, had one saloon for every 600 residents, while across the state in Walla Walla, it offered one saloon for every 348 inhabitants. By those numbers, Walla Walla was home to a much thirstier group of cowboys.

Around the years of 1868 to 1913, the state of Washington, and other newly established states and territories, discovered that about 90 percent of revenue came from taxes on liquor, beer, wine and tobacco. Walla Walla was no different than any other town in this era. At the monthly meetings held

by the Walla Walla mayor and his five councilmen, the city fathers noticed that of all the new businesses, the saloon business was the most active and its revenue was most essential to the life of their new town. This boom of alcohol sales would continue in Walla Walla, of course until Prohibition. In the twenty-first century, Walla Walla is booming once again with the revenue from the wine industry and tourism.

Historian Lyman described the miners who visited Walla Walla on the weekends from Idaho as "notorious for their heavy drinking, wild women, bawdy behavior—they were described as a Hobbesian state of nature."

The term *Hobbesian* refers to Thomas Hobbes, an English philosopher who argued that the only way to secure a civil society is through universal submission to the absolute authority of a sovereign. Lyman also said of Walla Walla and its miners and visitors: "This peaceful and law abiding Garden City of 1917, a center of homes and educational institutions, conspicuous for morality and comfort was about as tough a collection of human as could be found. It was indeed heads throng that poured in as the excitement grew and spread. The worst jostled each other on dusty and unsightly streets with their shacks and tents and saloons and dance."

And to think that longtime locals claim that our present-day wine tourists are bad.

As the early days of Walla Walla planted its roots, not only were there around thirty saloons, but there were also about a dozen storefronts selling wine and spirits, several cigar stores, a couple of cigar factories and a few breweries. The large and most colorful part of town included properties on Main and Fourth Streets, occupied by cigar, liquor and wine stores, hotels (many became brothels through the years) and saloons that also became morning stops for local farmers to find and hire laborers for the day. This area of downtown goes back to the earliest days, since it was part of the original town plat surveyed in 1859.

In the late 1800s, some of the earliest restaurants in Walla Walla were located on the same block that was notorious for cigar and liquor stores and "wild women"—Main and Fourth Streets. In the 1950s and early '60s, this section was often referred to as "Lower Main" or "Skid Row."

A row of small houses of "ill repute" linked on Rose Street and on the corner of Fourth and Rose Streets was also on the same block as the Idle Hour Restaurant. While madams Clara Harris and Josephine "Dutch Jo" Wolf were busy entertaining at the Hotel Louvre (later renamed the Ritz Hotel), a patron

could dine and be "idle" at the Idle Hour while waiting his turn. In 1913, Washington State passed a "Red Light Law," which led to legal action against the owner of the Louvre-Ritz Hotel, located at 214–16 West Main.

POSTED ON THE FRONT OF their building and daily menu were the words "Pies Like Mother Use to Make." This standard feature of advertisement could be a good thing, assuming that the potential customer's mother made delicious pies. The Mint Chop House, located on the northwest corner of Main Street and Fourth Avenue (formerly behind the F.M. Pauly building), opened its wood-frame building at the turn of the twentieth century.

One of the earliest Walla Walla pharmacists, H.E. Holmes had established the former and longtime Green & Jackson's Drug Store in 1872. He constructed the early restaurant building, eventually known to be the last and oldest remaining box-type stick building on Main Street.

In the late 1890s, one could dine at the Mint Chop House and pay one's bill with gold dust. When it came to dealing with coins, a diner paid for his full-course breakfast with fifteen cents.

As the song goes, "they paved paradise and put up a parking lot," and in January 1959, the old structure was razed. During the razing, it was discovered that the former Blalock Mill and Lumber Company was used for its construction; in the razing, old square nails were found.

FROM THE 1880s TO THE early 1900s, many of the buildings that housed restaurants were also hotels, such as the Delmonico, located at the Delmonico Hotel at 206 Main Street. The New York Restaurant was located in the Stine Hotel at 128 Main, with Joe Stiner as proprietor, advertising "White Cooks & Obliging Waiters."

In the Louvre-Ritz Hotel at 214 West Main was Olson's Restaurant. The *Up-to-the-Times Walla Walla* magazine, a monthly publication of the Walla Walla Publishing Company, quoted in its early 1900 edition that the owner of Olson's Restaurant was Alvin Olson, known for his "famous restaurant, a great caterer, and renowned poet, with over a quarter of a century of good business career to his credit." This space was followed by the Star Restaurant in 1905. The original building at 214 West Main no longer remains.

Also in the 1880s and '90s, the Bon Ton Restaurant at 16 Third Street advertised itself as "The most popular restaurant in the city. Tables are liberally supplied with every delicacy of the season."

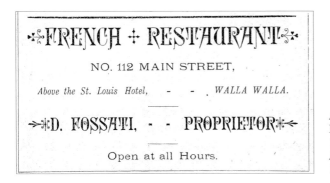

Advertisement from the French Restaurant, *Walla Walla City Directory.* V. Amp. Smith, Publisher, 1889.

If seafood was to your liking, there was the Oyster Grotto at 102½ Main, with Alex Young as proprietor. If you were more in the mood for late-night surf and turf, Van's Café at 117 West Main offered up steaks and oysters and was open all night.

Wanting something with a more patriotic flair? There was Uncle Sam's Restaurant at 102 Main with Samuel Hawkins, proprietor. The Red, White, and Blue Chop House on Fourth Avenue had P.G. Tefft as its proprietor. It advertised, "Everything is First Class."

There were other establishments of this era, including the Aurora Restaurant at 310 Main Street and the Comstock at 3 First Street. The Southern Café opened around this time and was located at 9 South Third Avenue.

If you think that Walla Walla was all about hardcore whisky drinking and woman-chasing, there were also restaurants offering fine dining for the genteel. There were two French restaurants. One establishment used a not-so-creative name for a French restaurant, known as "The French Restaurant" located above the St. Louis Hotel at 112 Main Street. The proprietor was D. Fossati. According to its advertisements, it was known as "the best in the city." The Restaurant de Paris had a bit more imagination when it came to names. This eatery was located at 106 Main, with its proprietor Adolphe A. Tellier.

To understand the present and future of Walla Walla, one must know Walla Walla's past.

Walla Walla County is tucked away in the southeastern corner of Washington State. It derived its name, loosely translated, from Wallulapum, the native language of the Walla Walla people, meaning "many waters." Not only is Walla Walla surrounded by the majestic Columbia River and

the winding Snake River, there is also the Walla Walla River with its many tributaries running through the county and the surrounding Blue Mountains.

Around 1824, Walla Walla Frenchtown (now Lowden) was established near the mouth of the Walla Walla River. This community was associated with the Hudson's Bay Company post established by French Canadians. These settlers have been noted for their contribution to Walla Walla's wine history.

In September 1836, Dr. Marcus Whitman, a physician and missionary from New York State, and his wife, Narcissa Prentiss Whitman, led the first wagon trains along the Oregon Trail. The party arrived in the Walla Walla area and established a mission. In an unsuccessful attempt to convert the local tribe to Christianity, the Whitmans and fellow missionaries were massacred by the Cayuse tribe, the result of an epidemic that the tribe believed the white missionaries purposely manipulated to poison their people.

During Dr. Whitman's short time in the valley, he was known to have dug the first irrigation ditch near the mission. He also planted strawberry and grape vines, as well as apple and vegetable seeds. Many of the seeds planted were those that Mrs. Whitman saved and dried.

Upon a visit to Fort Vancouver, located west at the Columbia River, before the Whitmans headed to their final home in Walla Walla, Mrs. Whitman had become enamored with the fort's large, prosperous gardens, as well as being a guest of lavish European-style dinners hosted by the Hudson's Bay Company. This was not a dining experience she had been used to in her travels, especially after being in a covered wagon for months eating dusty, dried meat. She would write to her mother, "The grapes are just ripe, and I am feasting on them finely. There is now a bunch on the table before me. I save all the seeds of those I eat, for planting, & of apples. Also I intend taking some young sprouts of apple, peach, grape & strawberry vines & from the nursery here."

After the massacre, the population of Walla Walla was developed around the U.S. military's Fort Walla Walla in the late 1850s, and on April 25, 1854, the Washington Territorial Assembly created the 1,299-square-mile county with Walla Walla as the county seat. The county's southern border is the state of Oregon, the eastern border is the state of Idaho, and the Snake River separates the western and northern border from Washington's Benton and Franklin Counties. The city of Walla Walla was granted a municipal charter in January 1862.

Settlers who followed Whitman would soon discover that this little valley in eastern Washington had all of the elements for a cornucopia of

agriculture. Wind-deposited silt, also known as loess, provided exceptional drainage. A long growing season averaging two hundred days provided a summer of long, hot days and cool nights, and there was an additional two hours more of sunlight per day, even compared to that in the state of California to the south.

Grain crops had an important role in the valley. Winter and spring wheat, as well as barley and oats, were the most prolific in the higher elevation surrounding the valley, which required little to no irrigation, and by the late 1890s, wheat was Walla Walla's leading crop. Today, wheat remains the leading and largest crop in the Walla Walla Valley, with an average of 300,000 acres.

The first nursery in Walla Walla was staked out around 1859–61, and apple orchards and vineyards were planted by the banks of Yellowhawk and Cottonwood Creeks, continuing to the border at Oregon. By the 1920s, the fruit orchard industry in the Walla Walla Valley had peaked. Not only were orchards growing well, but also gardens were prolific in the area around the city of Walla Walla. Large and bountiful gardens and orchards in the valley were producing alfalfa, apples, asparagus, cherries, corn, onions, radishes, rhubarb, strawberries and extraordinarily large melons and squash. The rich valley of Walla Walla would be known for years as the "Garden City."

The 1870s brought new growth to the Walla Walla area with the extensive immigration of Italians. There were opportunities for settlers to mine for gold, to purchase land and to engage in farming, especially what were referred to as "truck gardens"—farms raising produce meant to be sold at local markets. A few of the Italian settlers to Walla Walla would also plant wine vineyards for both commercial and personal use.

A French soldier by the name of Peter Pieri was stationed on the Island of Corsica. Upon his discharge from the French army, he secured an Italian seed that was common on the island. In the early 1900s, Pieri settled in the Walla Walla Valley and planted the seed of the "French" onion on his irrigated patch of land. Soon, his Italian immigrant neighbors noticed the exceptionally mild, sweet flavor of the onion, and by 1920, Pieri's neighbors adopted the sweet globe. Due to the low sulfur content and plenty of Walla Walla water, the famous Walla Walla Sweet Onion was born. Today, third and fourth generations of farmers still grow this crispy sweet bulb. The Walla Walla Sweet Onion is designated under federal law as a protected agricultural crop, and in 2007, the onion became Washington's official state vegetable.

THE NEWLY CHARTERED TOWN OF Walla Walla was abundant with tourism, jobs and, especially, entrepreneurs providing for the needs of their city and the people. It would become the highlight of the busiest of towns in Washington Territory. Shopkeepers would brag that their village had a larger population than any other town, even those located on the Puget Sound. This was true, as Seattle did not reach its boom until the late 1800s.

By 1916, the Walla Walla Commercial Club (similar to a chamber of commerce) identified the various and large amount of businesses and services, including food businesses such as wholesale manufacturers and retail. Wholesale businesses included the following: four candy factories, two creameries, two cheese factories, three flour mills, one fruit-drying plant, one ice manufacturer (to keep all of the food and beverages chilled), one meatpacking house, three fruit-packing houses, one pickle manufacturer and two vinegar manufacturers (using local fruit). The Commercial Club reported the following retail food businesses: three confectioneries, thirty-five groceries, five meat purveyors, six bakeries and twenty-two restaurants.

The oldest bank in the state of Washington, Baker Boyer Bank, was founded in 1869 and remains on Main Street today, continuing to assist in managing dollars for local businesses, including restaurants.

In the early 1900s, an *Up-to-the-Times Walla Walla* editorial stated that the growth and success of Walla Walla's agriculture and commerce was unusual during this time, as many other cities had to depend on food sources from several miles—and often several travel days—away.

It would appear that Walla Walla's early restaurants were among the first to provide their customers with a "farm to table" menu.

Today, Walla Walla is the largest city in the county and the twenty-fourth-largest city in Washington. According to the U.S. Census Bureau, as of July 2016, the population of Walla Walla County was estimated at 60,340, which included the city of Walla Walla's population, estimated at 32,132. Walla Walla is home to four colleges: Whitman College, Walla Walla University, Walla Walla Community College and Washington State Penitentiary—a "college for wayward dudes."

Some people think Walla Walla has changed, but if you look at the past and see Walla Walla's current success with our continued agriculture, pride in our historic downtown, tourism and nationally celebrated food scene, Walla Walla has come full circle.

2
Date Night

There is no sincerer love than the love of food.
—George Bernard Shaw

In the past, the difference between dining out for a couple instead of for the whole family was if the restaurant offered a dark lounge and some candlelight. An order of highballs between adults—or maybe even two highballs—before dinner would get the evening started. Among the events lounges in the past didn't offer was "Ladies Nights," with the thinking that "ladies" should never drink in the lounges or at a dining-room table without a man.

Many dining advertisements in the early 1900s, and even into the 1930s, '40s and '50s, boasted that their establishment was "classy" or "clean enough" for ladies or stressed that ladies should consider only having afternoon lunch at their establishments while the men dined in the evening to discuss business and politics.

The 1960s and '70s brought a new era, with women traveling mostly in packs on weekend evenings. Walla Walla certainly had its share of dining places offering a lounge, sometimes even a dance floor.

THE TOURISM OF MINERS, RAILROADERS and shoppers to Walla Walla from Idaho and Oregon warranted a few hotels. Many of the hotels located downtown also offered dining.

The Grand Hotel was located on the corner of First Avenue and Alder Streets. In November 1911, the newest hotel opened its doors to the public. The former Ransom building had previously been four floors of offices until owner J.E. Ransom agreed with the city to add a fifth floor offering ninety-eight rooms, including dining rooms. Ransom leased the building to proprietors and announced that they were "high class men of long experience in the hotel business."

The hotel's advertising made mention that the dining room was a place for the ladies to lunch at noon, the men to dine in the evening over a discussion of politics and banquets for service clubs and fraternities. Advertised as serving the "Best Food in the West," the Grand Hotel's dining room had an assortment of "grand fare," including Olympia oyster cocktails, oyster pan roasts, consommé, mock turtle soup and more than six styles of potatoes, along with a variety of fine cuts of steaks and chops. And for a little romantic ambiance, candlelight dining was advertised.

Through the years, the Grand Hotel would include a barbershop. In 1934, Walla Walla entrepreneurs James Raymer, a grocer, and Raymond Shelton, a clerk at Shep's Smoke Shop, opened a fountain lunch under the name of Raymer and Shelton. The new coffeeshop was located next door to the Grand Hotel at 17 East Alder Street. Raymer and Shelton's featured breakfasts, hot and cold sandwiches, beer and a hot cup of coffee. Raymer and Shelton even encouraged patrons, "don't forget… table for the ladies."

In the late 1940s, the fountain lunch changed ownership and the name became simply Shelton's. Eventually, the businesses disappeared, and in 1962, the Grand Hotel building was razed to the ground.

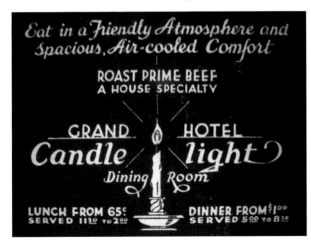

Dining by candlelight at the Grand Hotel dining room, 1950. *Courtesy of Joe Drazan, the Bygone Walla Walla Project.*

Left: Raymer and Shelton Fountain Lunch, April 1934. *Courtesy of Joe Drazan, the Bygone Walla Walla Project.*

Below: Hotel Dacres with buffet at 207 West Main in the 1890s. Schaefer's Bakery is next door. *Courtesy of Joe Drazan, the Bygone Walla Walla Project.*

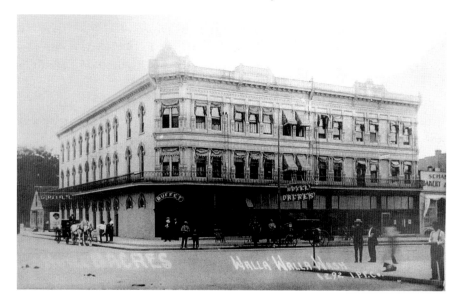

The former Hotel Dacres (the building still remains at 207 West Main Street) was built in the Victorian Italianate architectural style, and in 1899, owner James E. Dacres opened his idea of a first-class hotel. The hotel included a grill featuring Sunday dinners "fit for a king," as well as Christmas dinners offering soup, Olympia cocktails (seafood), roast turkey, baked duck, baked breast of chicken, sweet potatoes, "snowflake" potatoes, two varieties of bread dressings, an assortment of vegetables and, for dessert, hot mince pie and green apple pie. The hotel offered a

"Merchant's Lunch"—for thirty-five cents, a merchant could have fish or meat, a slice of pie and a cup of coffee.

In 1933, the Dacres Café opened under the management of Ben Ichikawa. As a celebration of the new management and menu, during the grand opening, free beer was served from 8:00 p.m. to 9:30 p.m. Later, it opened up the taps and sold free beer from 10:00 p.m. to 11:30 p.m. No doubt that half-hour break was needed to fill up the tanks and take a rest. Hotel Dacres operated until 1963, when it closed. No doubt the establishment was run clean out of beer.

During the same era, the Walla Walla Hotel opened in 1905 at 214 East Main Street. Its advertisements offered a "First Class Restaurant," as well as the tagline "Where your mother or daughter can stay with safety." The hotel closed in the mid-1970s. The building still remains.

THE FOUNTAIN GARDEN (PROPRIETOR GEORGE F. Hofer) at 31 East Main was known as the "Brightest Spot of Walla Walla." In the 1930s, it was the place for date night. The Fountain Garden had musical entertainment—a trio known as the Fountain Garden Trio, of course.

The Fountain Garden was the place to relax with a sandwich, a beer or a glass of wine, even a game of pool. It was a comfortable environment that advertised "tables and booths for ladies."

One thing Walla Wallans should interest themselves in is the erection of a fine large modern hotel. Good hotels do much to advertise a city; also never fail to attract much travel. I would like to see Walla Walla with a hotel, second to none in the Northwest.
—William McMurray, Passenger Agent of Oregon Railroad and Navigation Company Railroad (OR&N Railroad), 1915.

WALLA WALLA LISTENED TO RAILROAD agent McMurry when, in 1927, during the time of Walla Walla's greatest growth, a luxury hotel was planned for the corner of Second Avenue and Rose Street. It was named for local pioneer and missionary Marcus Whitman. More than two hundred Walla Walla businessmen supported the idea of a luxury hotel to encourage tourism. A Seattle real estate company offered to invest $300,000 in the construction of a hotel, with the stipulation that the community raise $150,000 in ninety

days. It succeeded, with the businessmen selling $100 shares of stock in just a few short weeks. In 1928, the doors of the Marcus Whitman Hotel opened, offering 174 guest rooms, ballrooms and dining. With the opening of the hotel, the city of Walla Walla passed an ordinance that no other structure could be built taller than the Marcus Whitman Hotel. This interesting city ordinance still stands today.

The Marcus Whitman became the finest hotel for hundreds of miles, drawing presidents, celebrities and dignitaries with its elegant rooms, friendly service and famous restaurant. Visiting guests in the twentieth century included Presidents Dwight D. Eisenhower, Lyndon B. Johnson and Richard M. Nixon; child actress Shirley Temple, George Reeves (TV's *Superman*), Walter Brennan (Academy Award winner and TV star), Chuck Connors (TV's *The Rifleman*) and musician Louis Armstrong.

Through the years, the Marcus Whitman Hotel saw many property owners and managers, and the establishment would fluctuate in terms of the quality of the rooms, and especially with the dining aspect. By the 1970s, the building became rather derelict in appearance, and from the 1970s to the mid-1990s, the hotel rooms were used for sustenance housing.

In 1999, local entrepreneur Kyle Mussman developed a new company, appropriately named Real Estate Improvement Company, and purchased the tallest building in downtown Walla Walla. He would share his vision with the city and the Port of Walla Walla. In the spring of 2001, the magnificent Marcus Whitman Hotel and Conference Center officially opened. Today, the hotel features a grand lobby, beautifully appointed rooms, an award-winning restaurant and a lounge featuring Walla Walla's finest wines.

During the lean years of the Marcus Whitman's dining existence, one of the more successful restaurants was Stuart Anderson's Black Angus. The restaurant opened its doors on June 29, 1973. The success story of the Black Angus restaurants started when Anderson, a former cattle rancher in Washington State, opened his first restaurant in Seattle in 1964. By the time the restaurant opened in Walla Walla, it was the seventeenth Black Angus location, with four more planned by the end of 1973.

The dining room decor was a blend of modern and western, with a maze of smoked plexiglass dining modules and barn wood walls. The lounge featured a stainless steel dance floor and cocktail tables, a mirrored ceiling, a disco ball, multilevel seating and more barn wood adorning the walls.

The success of the restaurant was in its simple steakhouse menu, consistent food and excellent customer service. The simple menu offered various cuts of steak and a seafood "catch of the day." Served with the meat entrée were

a green tossed salad and a baked potato. Extras could be ordered, such as deep-fried onion rings, deep-fried mushrooms, cheesy garlic bread and a selection of desserts.

Many locals were disappointed when the Black Angus closed its doors to Walla Walla on March 26, 1984. It had a good, nearly eleven-year run. Following the Black Angus's closing, its manager, Abe Matheny, took over the space and reopened the next day under the name Abrahams. By the end of December 1984, Abrahams would close after more than two months of financial trouble and with the Marcus Whitman's current property management contesting Abrahams' bankruptcy. The former Black Angus structure that was attached to the hotel is also long gone. Today, more than forty Black Angus restaurants remain.

OVER IN THE EASTGATE AREA of town, on 405 Wellington Avenue, businessman George Gradwohl purchased the Top Hat restaurant in 1943 from Leonard Schiffman. (Before the 1950s and the Wellington Avenue address, this stretch was known as Highway 410, which led to the town of Waitsburg in Walla Walla County.) One of the keys to the Top Hat's later success was its advertisements suggesting it was easier to drive to Eastgate than it was to find parking downtown. During that time, downtown parking was all parallel. Through the years, the space would go through a few changes, and on Friday, October 16, 1964, the doors were opened to the Maverick Restaurant, including its new Frontier Room lounge.

The newest space in town had been purchased by a group of local businessmen from W.F. Rhoads, who had established the business a few years before the newest change. The lounge had a dance floor and a piano bar. Their menu was typical of its western title, with steaks, chops and seafood.

In the early 1970s, the western building would take on a new name but keep the same persona. The Steak-Out had a difficult time understanding what it wanted to be when it grew up. By day and early evening, one could dine well, with professional, well-skilled servers. Tables were intimate and candlelit—perfect for couples. The menu kept the popular surf-and-turf plates but also had prime-rib sandwiches, chicken cordon bleu, chicken Kiev, house-made soups and rice pilaf. Pilaf? This fancy rice was something we hadn't read much about on other menus around our little hamlet. We were more about potatoes.

One side of the building featured the fine and civil side of dining. And, as soon as the weekend band started its tunes, emulating the sounds of the

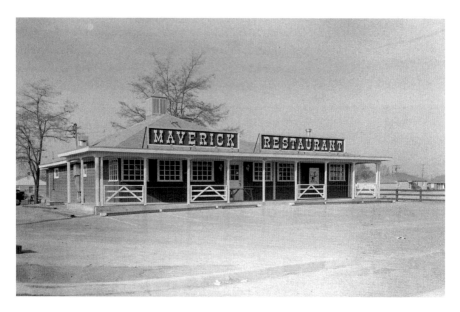

The Maverick on Wellington Street, November 8, 1961. *Courtesy of Joe Drazan, the Bygone Walla Walla Project.*

Doobie Brothers and Bachman-Turner Overdrive, the other side of the building unintentionally became a dive bar for underage patrons, including those a few months' shy of turning the legal drinking age of twenty-one. It was also a hangout for the newly divorced looking to get their dating and dancing feet wet. The women's bathroom was often filled with young women repairing their makeup or shedding a few tears. Outside of the bathrooms was a public phone—and usually a long line: late-night patrons waiting to check in with their parental units asking for an extension of their curfew or calling friends to meet them at the Steak-Out or downtown at another popular "pick-up" place, the Black Angus, with the stainless steel dance floor. Not that this author knows anything about that *other* side of the Steak-Out building.

Sadly, in the early 1980s, a fatal stabbing took place at the Steak-Out, and this incident gave the business a new nickname around town, known unfortunately as the "Stab-Out." It's because of this curse of a nickname that, around 1982, the Steak-Out would close its doors. Shortly after, other restaurants and a tavern would try to "stake and stab" their claim to Walla Walla's dining fame, but at this time, the building remains empty.

THE DISTINCTIVE WHITE BUILDING ON the downtown corner of Second Avenue and Main Street started its life as a dry-goods store in the late 1800s and would later house the Third National Bank of Walla Walla. One of the most important things the building would eventually house was food.

In 1936, Mitchell's Bar-B-Q, run by Joe Mitchell, was known as the "popular corner in Walla Walla." Its small menu consisted of barbecue meats, the Coney Island (a hot dog with a spicy sauce) and the Wimpy Burger, named after J. Wellington Wimpy, a character from the *Popeye* cartoon. Affectionately known as Wimpy the Moocher, he ate a steady diet of hamburgers while begging the burger vendors, "I'd gladly pay you Tuesday for a hamburger today." Joe also tried to romance the ladies with "fancy meals" of chicken à la king instead of barbecue and burgers. Well, Joe stuck around for a couple of years until he hung up the shingle around 1944.

On September 1946, local downtown businessman Harold Jackson and his managing partner, Claude Williams, opened the Corner. Their first advertising to announce the grand opening stated that one of the many features was a "Lady Cook" preparing home-cooked meals in their white, new, private basement kitchen.

Known as the Jackson Building at 2 West Main, the bottom level was the restaurant, but upstairs was also a jeweler, an optometrist and a credit association. In the early 1950s, a "fancier" evening menu arrived with dining

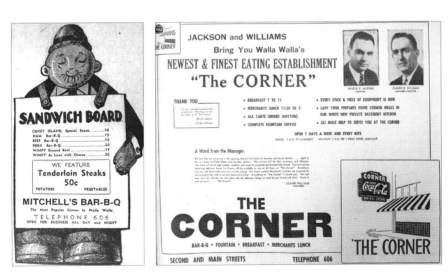

Left: Mitchell's BBQ menu, August 1937; *Right*: The Corner opens, September 1946. *Courtesy of Joe Drazan, the Bygone Walla Walla Project.*

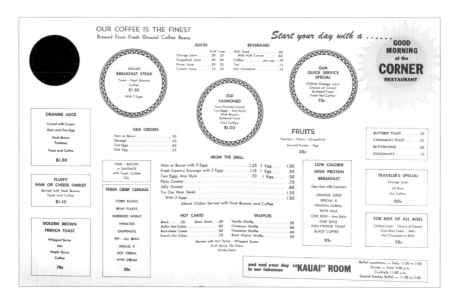

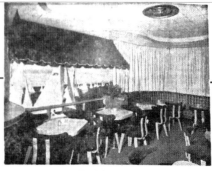

Above: The Corner Restaurant breakfast menu, 1960s. *Courtesy of Joe Drazan, the Bygone Walla Walla Project.*

Right: The Corner advertising the new Regatta Room, February 1952. *Courtesy of Joe Drazan, the Bygone Walla Walla Project.*

in the new Regatta Room. Eventually, the Corner would offer to their guests a lounge, the Kauai Room, with bar service until 2:00 a.m.

The menus would vary through the years but remain somewhat consistent, serving breakfast to downtown employees; sandwiches and salads at noon; and, during the evening, steak, chops, seafood and burgers. For a time, the Corner even served waffles for breakfast or dinner with a selection to choose from: vanilla, cinnamon, black walnut or chocolate.

Several years later, the Corner Restaurant would take on a remodel. In August 1960, the building reopened as The Corner Restaurant and Terrace Room. The first floor had a modern and colorful look, with new dining tables and a lunch counter. Installed near the Main Street entrance was

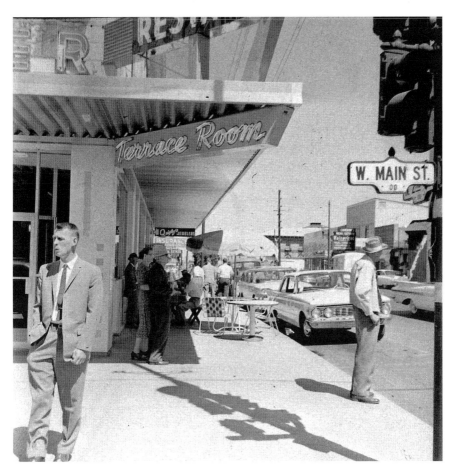

Downtown sidewalk sales, Corner Restaurant and Terrace Room, at Main and Second Streets, June 1961. *Courtesy of Joe Drazan, the Bygone Walla Walla Project.*

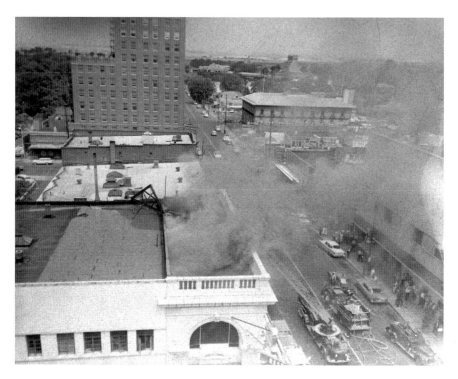

A fire at the Corner, June 1963. *Courtesy of Joe Drazan, the Bygone Walla Walla Project.*

a suspended contemporary steel staircase with a chandelier hanging from above leading to the new Terrace Room, where one could lounge with a cocktail. A three-stop food elevator connected to the main food's preparation quarters in the basement would travel up to the two dining floors. Instead of offices, the upstairs dining room was used for buffet lunches and Sunday brunches. The Corner became the home of the yearly Rotarian Restaurant Day fundraiser for many years.

Some might say this building was jinxed when it came to the restaurant business. In the late evening of October 2, 1974, the Corner Restaurant suffered a serious blaze that destroyed the Terrace Room while under the new and last owner, Ray Palmer. This was the seventh fire at the Corner since 1959 and the third serious blaze.

Shortly after the fire, the building became the location for an insurance business and continues in that mode today—even selling fire insurance.

DURING THE GROWTH OF WALLA Walla, it became a strong settlement for Italian and Chinese families but also a settlement for Germans leaving Russia. From 1882 to 1920, several German families settled in a small southwest area of the city known as Germantown. Among the three hundred German families, there were several entrepreneurs, and they would open a variety of businesses.

Around 1915, the Hill family opened a grocery on Maple Street. Later, John David Frank established a grocery and a meat market just around the corner on Fourth Avenue, creating a bit of competition with the Maple Street grocery. Years later, the Delishus Bake Shop opened in the neighborhood. Located on the corner of Chestnut Street and Second Avenue, it was a staple for baked goods in the neighborhood. The owners, Mr. and Mrs. Alex Frank and their sons Gene and Dick Frank, offered breads, sandwich rolls, prune cake, strudel and even wedding cakes; but the most memorable fare were the warm, glazed, yeast doughnuts that didn't last long once they were placed in the display case. (A bit of trivia: Gene and Dick were both well-loved grade-school principals for many years for the youngsters who grew up during the baby boomer era.)

With a Germantown in the valley, one would think there would be some German-style food available. The building at 628 West Main on the corner of Ninth Avenue would see a variety of ethnic restaurants through the years, from Italian to Chinese to Mexican. And a female entrepreneur originally started selling only hamburgers. Maxine Harding sold a hamburger with fries for fifteen cents at that busy corner.

Businessman A.J. "Abe" Mathison later took over the building from Harding. He would add more than hamburgers to the menu, serving full-course meals during the war years. More than three thousand men were stationed at the Walla Walla Air Force Base during World War II.

One of the more outstanding of the Walla Walla restaurants during the twentieth century, especially on the Ninth Avenue corner, was the Heidelberg Villa. This German-themed restaurant and lounge was started in the spring of 1961 under the ownership of Kurt Reithmayr, who also owned longtime local business Kurt's Decorative Services. The restaurant had previously been an Italian restaurant known as the Villa. The Continental Room was a cocktail lounge featuring a "newfangled" box known as a television. In that era, to see a television in a bar was uncommon

The Heidelberg Villa not only had one chef, but also in the kitchen was Hilde from Frankfurt, Germany, who prepared German-inspired favorites such as bratwurst mit weinkraut, sauerbraten mit kartoffel, wiener schnitzel,

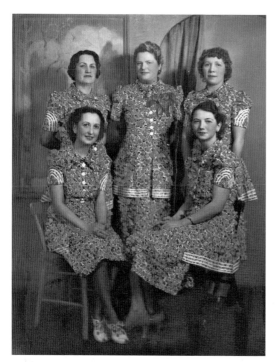

Left: Maxine Harding (*center, standing*) with staff at the Villa, 1936. *Courtesy of Beverly Cunnington.*

Below: At the Villa on Ninth and Main. Maxine Harding (*center*) and staff celebrate the Whitman centennial in 1936. *Courtesy of Beverly Cunnington.*

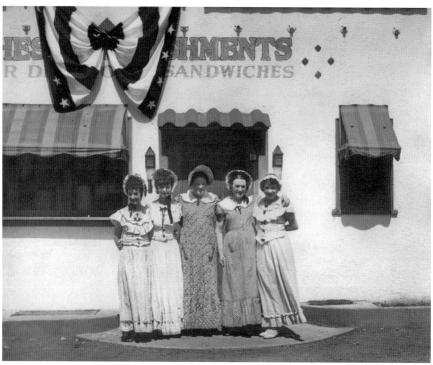

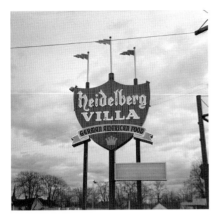

Left: The corner sign on Ninth and Main at the Heidelberg Villa restaurant, February 1, 1961. *Courtesy of Joe Drazan, the Bygone Walla Walla Project.*

Middle: The Heidelberg Villa at 628 West Main Street, November 1963. *Courtesy of Joe Drazan, the Bygone Walla Walla Project.*

Bottom: The dining area at the Heidelberg Villa Restaurant, March 1961. *Courtesy of Joe Drazan, the Bygone Walla Walla Project.*

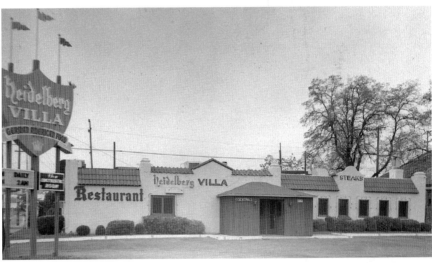

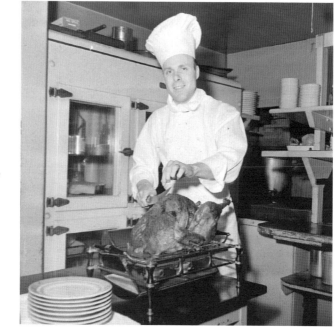

Right: Chef slicing a turkey at the Heidelberg Villa, March 1961. *Courtesy of Joe Drazan, the Bygone Walla Walla Project.*

Below: Wednesday night buffet at the Heidelberg Villa Restaurant, July 1961. *Courtesy of Joe Drazan, the Bygone Walla Walla Project.*

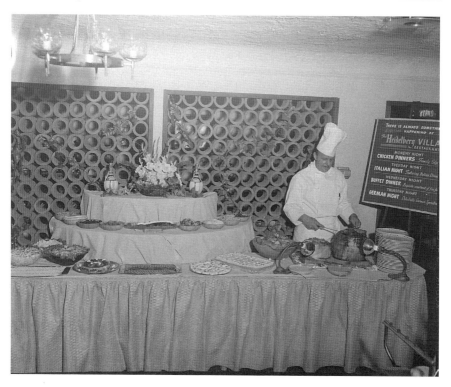

rippchen und kraut and apple strudel. Chef Richard Cole, a culinary school graduate, created other "fancy" cuisine for its time: Caesar salad tossed at the table, fillet of sole margarete, veal croquettes en wine sauce, tenderloin brioche with brandy, chicken liver supreme, Monte Cristo sandwich à la Francais and, for dessert, baba au rhum flambe. So much for the old saying, "too many cooks in the kitchen."

Reithmayr later sold the Heidelberg Villa to Ron and Mary Starr, who would create a new lounge known as the Gold Rush Room. Around 1976, the Heidelberg shuttered its doors, and a new dining vision was created on the corner. In December 1977, the Forum opened with a Greek-Italian theme. The exterior of the building was remodeled with Greek columns added to the front and ornate crown molding around the roofline. Keeping with the theme, the wait staff wore togas. The menu was steaks and seafood and several garlic-laden entrées. It was a short-lived project; more than six months later, the Forum closed its doors on July 9, 1978.

THERE'S A LOT TO BE said about this favorite lunchtime and late-night hangout. Just about every longtime local can share a story about the Red Apple Café: from the Rotarian businessman who volunteered for the Restaurant Day fundraiser to couples after midnight enjoying the tickling of the ivories with local singer "Delores at the Keyboard."

Fondly known as "The Red" from the year it opened in 1944 until it closed in June 2000, this dining spot and lounge was a downtown anchor as well as a popular late-night hangout for many generations of Whitman College students. Over the decades, the business, especially after the 1980s, endured several building and business owners and remodels. Unfortunately, toward the end, it met its demise after taking on a gambling license, liens and health department risks.

This central dining spot in the heart of downtown had a long history. It originally started in the 1930s as the Special Café. Well known Walla Walla restaurateur A.J. "Abe" Mathison purchased the business and renovated the old building by lowering the high ceilings. He even gave the diner a new name: the Green Apple Café.

Somewhere between developing the name and the actual opening, the name changed to the Red Apple Café. Mathison opened the new venture with partners George Goss and Sam Raguso. At its opening, the café was advertised as "Walla Walla's Ultra Modern Café, Catering to People Who Care—7 a.m. to 1 a.m." Around 1947, Sam Raguso became the sole owner

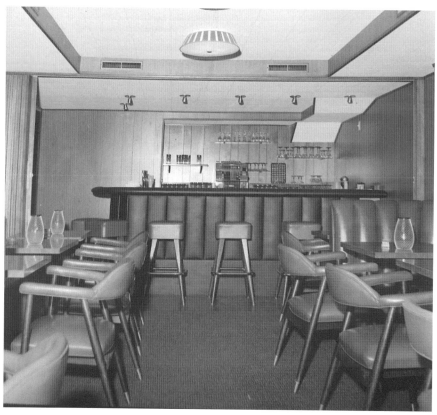

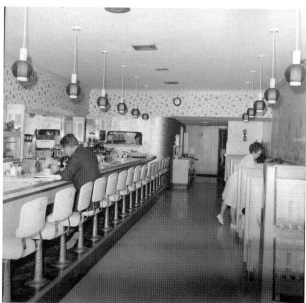

Above: The remodel of the Red Apple lounge, October 1963. *Courtesy of Joe Drazan, the Bygone Walla Walla Project.*

Left: The Red Apple lunch counter and dining booths. October 1963. *Courtesy of Joe Drazan, the Bygone Walla Walla Project.*

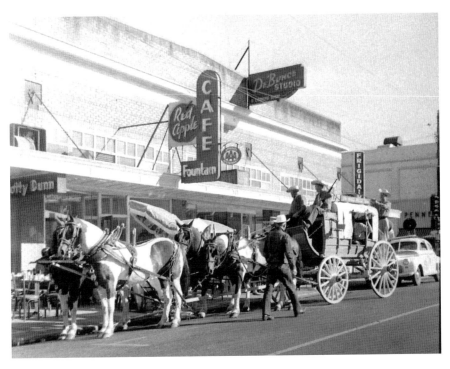

Walla Walla Frontier Days parade with the 59ers stagecoach in front of Red Apple Café, August 1959. This is proof that Walla Walla is more than a "one horse town." *Courtesy of Joe Drazan, the Bygone Walla Walla Project.*

until he died in 1978. His son Alan joined Sam in 1973, and after Sam's death, Alan continued his father's hospitality until he sold the popular landmark, known for its signature apple logo, in 1982.

Those who were looking for a colorful evening out on the town would often say "follow the rainbow," which meant starting at the east end of town at the popular Blue Mountain Tavern (The blue), then on down Isaacs Avenue to the Green Lantern Tavern (The green) and finally ending the evening with an early breakfast at "The Red."

Its name echoed France's second-favorite city. Instead of the Left Bank wine region of Bordeaux, located near France's Garonne and Gironde Rivers, this Left Bank was located near Walla Walla's Mill Creek, which flows through the center of downtown.

The corporation owners Phyllis Pulfer, Theron E. Smith and Daniel N. Clark opened the Left Bank in December 1977 on what used to be known

as the Fidelity Plaza, now First Avenue Plaza at 13½ East Main. Eventually, Phyllis and her husband, Bob, became sole owners.

Walla Wallans were treated to gourmet dining in true European fashion, especially with old country French classics. The atmosphere was warm and inviting, with soft candlelight and a charming assortment of mismatched antique wooden dining chairs and tables. The place was perfect for anniversaries or for impressing a date. There was also outdoor dining on the plaza with the sound of the creek nearby.

The restaurant gave prominence to its house-made soups of French onion and fresh seasonal soups such as gazpacho. Its fresh and creamy cucumber salad dressing was a favorite of many. Quiche, crepes and even pasta dishes were on the menu. Oh, my! And the desserts, all made from scratch, including crème brûlée and French silk pie.

The restaurant became a family project and sometimes even recruited a few friends. Nadean Pulfer, Phyllis and Bob's daughter, shared how she ran errands for the restaurant, procuring large beef bones from the butcher at the former Boy's Market on the corner of Alder and Wilbur Streets. The bones were later used to make the rich broth for the Left Bank's classic French onion soup.

Left Bank menu. *Courtesy of Nadean Pulfer.*

The Left Bank was also known for its wine selection featuring many local labels that were just getting their start. Today, those same wine labels, Leonetti Cellar and Woodward Canyon Winery, are known as high-end, world-class wines.

The restaurant was later sold to the Gibeaux brothers, and within a couple of years of the sale, one day in the winter of 1984, the restaurant doors closed abruptly and everything went to auction.

IT WAS THE BEST-KEPT SECRET in Walla Walla. The highest quality of food was always presented in an artful manner and executed out of a newly remodeled kitchen that was a former funeral home embalming room. The difference in Chef Adrian's Coquilles St. Jacques—a dish of scallops prepared with mushrooms, cream and butter—was his final touch of a sprinkling of caviar.

Partners Jack Laughery and Adrian Phipps purchased the Rees Mansion, located on the corner of Birch and Palouse Streets, in 1976. Ten years later, they opened up the bed-and-breakfast. Between the two partners, they had more than fifty years in the restaurant business, with Jack overseeing the bar and Adrian using his professional chef and baker experience in the kitchen. The neoclassical turn-of-the-century mansion with the perfect landscape and abundant rose garden was built in 1896. It had been a funeral home for several decades before it became Walla Walla's first bed-and-breakfast.

The mansion was filled with an eclectic assortment of antiques that Jack and Adrian had collected through the years. The dining room was open to the public, not just to the Rees Mansion's B&B guests. The lounge had been a former funeral home slumber room; instead of caskets, the new lounge was intimate and well-appointed with private sitting areas styled with antique Queen Anne chairs and coffee tables. The drinks were all free pour, using the finest ingredients and liquors.

In June 1990, Chef Adrian died due to congenital heart disease, leaving behind a role that was so essential to the personality of the business. Jack continued to run the business, taking on a few new employees. He finally announced that the beautiful old house was for sale and that he would close its doors to the public on May 31, 1991. The grand old relic is now a private home.

LAST BUT NOT LEAST, THE Oasis, later known to many locals as the "O," had been serving up hearty plates to the Valley for many generations. There's

a legend that at this little Oregon roadhouse, located just a few feet from the Washington side of the state's border in Walla Walla County on old Highway 339, customers often arrived via horse and buggy. That scene would certainly describe an era from the past, but then again, if you're familiar with Walla Walla, today it's no big deal to see a horse and buggy parked downtown next to the newest sports car or luxury import. Why? Because this is how the Walla Walla Valley rolls.

In 1907, Walla Walla also rolled—down the track, down the trolley track to our neighbors at Milton-Freewater, Oregon. Of course, back then, there were two towns: Milton and Freewater. Finally, the two little towns put their differences aside and became one. That's another story. But in the meantime, a round trip to Milton and Freewater via the Walla Walla Valley Traction Company would cost the traveler forty cents for ten miles coming and ten miles going. This beautiful countryside trip with the scenery of orchards and gardens and a view of the Blue Mountain foothills would also just happen to trolley by the Oasis.

Through the history of the Oasis we watched changes and growth; the eras often dictated the changes, from the 45s on the jukebox playing honky-tonk to cigarette vending machines, from gambling machines to a keno room. And that doesn't even describe the extensions of odd-looking dining rooms that kept growing beyond the original little white stucco-façade roadhouse.

It was once estimated that 75 percent of the Oasis's business came from the Walla Walla Valley—the Washington side—especially on the weekends. It was one of the few places around where a customer could be guaranteed that the liquor bar opened early at 9:00 a.m. and closed late at 2:00 a.m. People who weren't familiar with the Oasis often thought of it as a rough little joint of a tavern; some of its neighbors avoided it for years until finally braving it and taking a step inside, only then surprised to see a rather conservative and quaint dining area serving great food.

Around 1934, owner Ed Selby was known to visit with his diners and sometimes even drop a pair of dice on a dining table and suggest to his guest to gamble "double or nothing." If the diner rolled in their favor, Ed would comp the winner a meal. However, if the dice didn't roll in the diner's favor, the unfortunate diner would have to pay double for their meal ticket.

The menu mostly consisted of meat—huge, bloody cuts of beef—yet still the kitchen was conscientious of using fresh and seasonal produce. After a delivery of local produce, one might even see the farmer or farm crew resting at the bar during lunch, dining on a beer and a whiskey chaser or maybe even a sandwich.

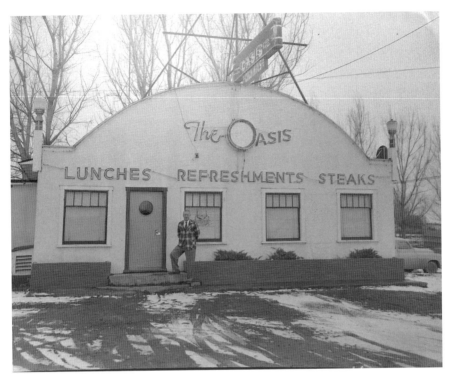

The Oasis, with owner Ed Selby, February 20, 1957. *Courtesy of Joe Drazan, the Bygone Walla Walla Project.*

The most talked about piece of beef weighed seventy-two ounces. Selby allowed his customers to take a gamble on that meal, as well. If a customer could polish off the seventy-two-ounce steak along with the baked potato and the rest of the "fixin's"—side salad, bread roll and a cup of coffee—the $12.50 plate of cow and all the trimmings was free.

There was another piece of beef that wasn't exactly from a cow but guaranteed not to "steer" you wrong—Rocky Mountain oysters, sometimes known as "Prairie Oysters" or calf fries. Yup, beef testicles that were peeled, coated in flour, seasoned with salt and pepper and fried. They were served with cream gravy and 'taters. It was a meal only for the brave—or drunk.

Of course, bull wasn't the only thing on the menu. Besides the turf, the Oasis offered surf. A popular choice was the Captain's Plate, a platter of fried prawns, scallops, oysters, crab legs and halibut. Of course, this platter wouldn't be complete without French fries and buttered toast. (I remember the Captain's Plate being a favorite of my father's.) There were other seafood

The Oasis dining room, November 1963. *Courtesy of Joe Drazan, the Bygone Walla Walla Project.*

The Oasis bar, February 20, 1957. *Courtesy of Joe Drazan, the Bygone Walla Walla Project.*

Left: Taking the Oasis seventy-two-ounce steak challenge, January 14, 1964. *Courtesy of Joe Drazan, the Bygone Walla Walla Project.*

Below: The winner of the Oasis seventy-two-ounce steak challenge with Ed Selby and Melvin Franklin, cook. *Courtesy of Joe Drazan, the Bygone Walla Walla Project.*

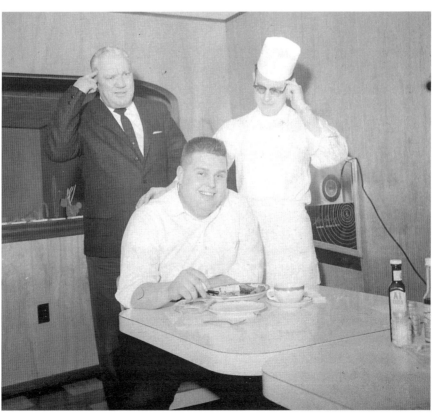

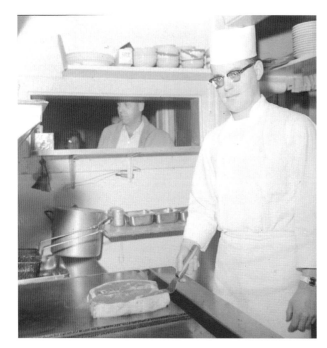

Left: Melvin Franklin, the Oasis cook, searing up a seventy-two-ounce steak, January 14, 1964. *Courtesy of Joe Drazan, the Bygone Walla Walla Project.*

Below: The Oasis bowling team enjoying dinner, January 14, 1964. *Courtesy of Joe Drazan, the Bygone Walla Walla Project.*

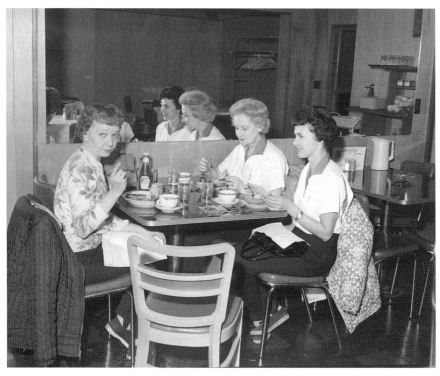

offerings, such as abalone, a deluxe oyster sandwich, shrimp and crab cocktail and—while this species didn't exactly jump from the sea—frog legs.

Chicken and dumplings served family style was also a customer favorite, and if that wasn't enough chicken, the diner could feast on sides of fried chicken gizzards, livers and giblets.

Locals Pat and Jim Koch purchased the Oasis from Ed and Ruby Selby in 1987 and continued the legacy. The Kochs implemented a few changes to the old roadhouse, such as adding more dining space, and a few small changes to the menu, keeping up with the times of their customers' palates. The Kochs would continue the success of this longtime and beloved institution until they retired in April 2005 and sold it to out-of-towner David Beale and his partner. Sadly, the old roadhouse closed in February 2013. At this time, the old building still remains empty, filled only with old ghosts and stories of the past. Every so often, a rumor will come around that the old roadhouse is reopening, but until then…

3

How We Roll

I was eatin' some chop suey with a lady in St. Louie.
—*Albert the Alligator,* Pogo *comic strip*

And speaking of chop suey, did you know that this favorite dish on many American Chinese menus is actually not a part of authentic Chinese cuisine?

Chop suey is a dish consisting of meat—often chicken, pork or even ground round—that is cooked quickly with vegetables such as bean sprouts, cabbage and celery and bound in a starch-thickened sauce. It's then served on top of fried crunchy noodles or steamed white rice, or both.

There are many legends about how this dish originated. One story says that in the 1860s, a Chinese cook in a San Francisco restaurant was forced to serve something to drunken miners after hours when he had no fresh food available from the workday. To avoid a beating, the cook threw leftovers in a wok, and the miners happily feasted on the meal. When the men asked the name of the dish so they could request it in the future, the cook replied, "chopped sui."

Another story claims that it was invented in the nineteenth century by Chinese American cooks working on the transcontinental railroad. There are several other similar versions.

At this time, there is no strong evidence for any of these stories. Food historians suggest that these similar but conflicting stories are a "prime example of culinary mythology."

Chinese immigration to America can be divided into three periods: 1849–82, 1882–1965 and 1965–present. During the first period, Chinese immigrants arrived in the United States to work as miners and railroad workers. Chinese settlements took place mostly in California and eventually in other western states: Idaho, Oregon and Washington. The first Chinese to settle in Walla Walla arrived in 1872. Many were former textile workers and farmers who were forced out due to importation of the textile industry, farmers forced off their land and persons displaced by military conflicts.

Walla Walla became a major jumping-off point for the men on their way to the mines and became a haven for those coming from the mines. Many of the men who settled in the area became manual laborers constructing the Dorsey S. Baker Railroad (also founder of Baker-Boyer Bank). This track would travel thirty-two miles from Wallula in Walla Walla County, located on the left bank of the Columbia River approximately twenty miles downstream of the junction of the Snake River and Columbia, then onward to the city of Walla Walla—and back.

Soon the area experienced another wave of Chinese immigration, this time businessmen involved in small enterprises, domestic workers and truck farmers. The Chinese settlement in Walla Walla grew to upward of five thousand people living in what was referred to as "Chinatown." This area was located on Second Avenue between Main and Alder Streets. Also during this time of new immigration, the center of activity for the Chinese expanded as a two-story brick building was constructed at Fifth Avenue and Rose Street. This new structure, the Pacific Enterprise Building, also known in the community as the "Chinese Building," was used as a community building for the local Chinese population. This inclusive marketplace contained as many as seven stores, including a grocery, department stores and traditional artwork stores, as well as upstairs apartments. Other ambitious enterprises through the early 1900s would include several traditional Chinese laundries, dry-goods stores, druggists, a medicine manufacturer and several restaurants serving traditional yet Americanized Chinese cuisine. It was also very common for many Chinese to be employed as cooks for local families.

Chinese New Year, a spring festival in China, became a memorable event in downtown Walla Walla, with parades and traditional Chinese ceremonies.

The population of Chinese immigrants decreased significantly after the completion of the railroad and the passage of the Chinese Exclusion Act of 1882. This law was then extended by the Geary Act in 1892. The Chinese

Exclusion Act was the only U.S. law to prevent immigration and naturalization on the basis of race. These laws not only prevented new immigration but also brought additional suffering, as they barred the reunion of thousands of Chinese men already living in the United States with their families abroad, and in many states, Chinese men were prohibited from marrying Caucasian women. One law even prevented the Chinese from owning land. This law was eventually repealed in 1943, although large-scale Chinese immigration to America did not occur again until 1965.

However, in the Walla Walla area, a strong Chinese community remained, and many Chinese moved into the valley to become gardeners and farm laborers. An organized group of vegetable gardens and dwellings was established in what was then known as the "bottomlands," today known as The Dalles Military Road. There were an estimated twenty-five Chinese truck gardens, with each employing between eight and nine Chinese laborers. Unfortunately, because they could not legally own land in the United States, the number of Chinese farmers in the Walla Walla area began to decrease after 1920. By then, a large number of Italian immigrants had moved into the valley and began buying land to farm themselves, which at the time due to the Geary Act, the Chinese could only rent.

In 1947, the Pacific Enterprise Building was purchased by a local non-Chinese businessman. He closed the living quarters, forcing around ninety Chinese to find housing among the general Walla Walla population. An exodus of the Chinese population began, and the Pacific Enterprise Building was razed in 1962. However, a small community of younger Chinese and their families remained in the valley. In spite of the decrease, Walla Walla was still regarded as having the largest Chinese population of any city in Washington State east of the Cascade Mountains.

Around 1907, Charles Ong was one of the first Chinese restaurants mentioned in the archives of Walla Walla. In the 1920s, the Silver Café, owned by Chinese proprietor Edward Hoy, would open its doors, serving American and Chinese fare from 6:00 a.m. to 2:00 a.m. from the address of 208 West Main Street. This area was also known as the notorious "red light" district. These café dining hours were convenient for the guests at the nearby hotel before and after they were "entertained." Eventually, the Silver Café would move next door to 206 West Main and would continue until 1962, when the Silver Café became the Silver Tavern. By 1966, the Silver Tavern became the Lamplighter Tavern.

Shanghai Law & Co.

The only first-class Chop Suey and Noodle Restaurant in the city.

A place for ladies and gentlemen·

Over Sims Grocery, Fourth and Main.

NOODLE GRILL	The only first-class chop suey and noodle restaurant in the city. A place for ladies and gentlemen. SMAIL'S OLD STAND, 3 W. MAIN ST., WALLA WALLA We serve a fine merchant's lunch from 11 until 1 o'clock and short orders at all hours.

Top: Shanghai Law advertisement, April 1911; *Bottom*: Smail's Noodle Grill advertisement, 1914. *Courtesy of Joe Drazan, the Bygone Walla Walla Project.*

In the early 1900s, there were other Chinese cafés in business on the notorious West Main block: Shanghai Low (Law) Noodle Co., "First Class" Noodle Parlor at Fourth and Main Streets and the Noodle Grill, which advertised "A Place for Ladies and Gentlemen," located at 3 West Main (formerly Smails Grill). Over on 9 South Third Street was the Oriental Café, serving classic Chinese American fare.

The On Fong Low Noodle Grill was located at 24 West Alder. From its kitchen came chop suey "in different styles" as per the menu and several dishes that featured lobster and oysters. On Fong Low Noodle Grill was also ahead of its time, with its "fusion menu" of chicken hot tamales.

In the 1950s, the Pagoda Café opened with Johnny Hoy in the kitchen at 213 West Main. Its advertising kept the public anxious and awaiting the newest thing to come to Walla Walla: the "Egg Roll."

ON DECEMBER 18, 1928, ONE of Walla Walla's newest Chinese restaurants opened. The Nanking Noodle Factory was owned by Lue Tec. Dining hours were 11:00 a.m. to 2:00 a.m. In the future, the location would eventually become very relevant to many locals, especially to the baby boomer generation. Tec advertised private booths and "sanitized and modern Frigidaire services." It would appear that this service was a transfer literally

Mary's Café advertisements, February 1947 (left); November 1946 (right). *Courtesy of Joe Drazan, the Bygone Walla Walla Project.*

from blocks of ice to keep perishables chilled to an electrical refrigeration service. Nanking Noodle Factory remained in business until the death of Lue Tec in the mid-1940s.

Tec's daughter Mary Lee took over the restaurant and, in 1946, she changed the name. Mary's Café featured American and Chinese cuisine. On Thanksgiving, Mary's was open and featured the traditional turkey and all the trimmings.

BILL YEW ENG WAS A well-known local with a story that was typical of those imposed upon by the oppressive Chinese Exclusion and Geary Acts. He was born in 1916 in Canton, China. (This city is now known as Guangzhou.) When he was fifteen years of age, his father, Jam Y. Eng, brought him to the United States, where they would make their home in Walla Walla. Bill's father had already emigrated from China. He operated a pharmacy and a general store in Walla Walla's Chinatown.

He returned to Canton, where he would meet and marry Rose Fong in 1935. After less than a year of marriage, unfortunately, Bill returned to Walla Walla alone in hopes of finding work to support his new wife. Due to the U.S. immigration laws at the time, Bill was unable to bring his new bride back to his home in Walla Walla. As a testimony to their vows, they were separated for more than eleven years.

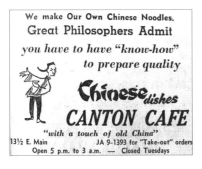

We make **Our Own Chinese Noodles.**
Great Philosophers Admit
you have to have "know-how"
to prepare quality

Chinese*dishes*
CANTON CAFE
"with a touch of old China"
13½ E. Main JA 9-1393 for "Take-out" orders
Open 5 p.m. to 3 a.m. — Closed Tuesdays

Left: Canton Café advertisement, February 1963; *Below*: Canton Café to the left and located on the second story. Carrousel Café on First Avenue and Main Street, June 1967. *Courtesy of Joe Drazan, the Bygone Walla Walla Project.*

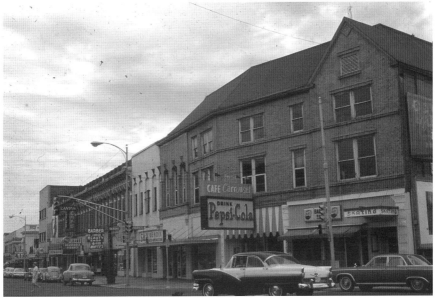

After Bill served in the U.S. Army, he was eligible for United States citizenship. Finally, in 1948, after their many years of separation, Bill was able to bring Rose to her new home in Walla Walla.

Shortly after Rose Eng arrived in the new country, the Engs purchased Mary's Café, located upstairs at 13½ East Main Street. They reopened it as the Canton Noodle in October 1949.

For years, until the day the Canton finally closed, it was known as the best-kept secret for late-night or early-morning dining. The café hours were from 5:00 p.m. to 3:00 a.m., making it a perfect place to grab some sustenance, especially after a late evening of bar hopping. There was no sign on the front door, but once in the entryway of the narrow stairwell, the hungry customer was greeted by white tile on the floor and "Noodles Grotto" spelled out with black tile. Up the staircase to the second floor and through the door into the

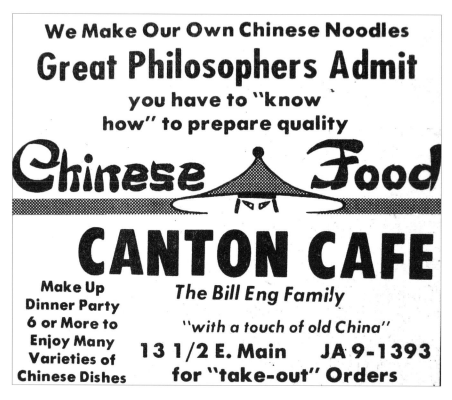

We Make Our Own Chinese Noodles

Great Philosophers Admit
you have to "know how" to prepare quality

Chinese Food

CANTON CAFE

Make Up Dinner Party 6 or More to Enjoy Many Varieties of Chinese Dishes

The Bill Eng Family

"with a touch of old China"

13 1/2 E. Main JA 9-1393
for "take-out" Orders

Canton Café advertisement, February 1971. *Courtesy of Joe Drazan, the Bygone Walla Walla Project.*

dining room, one was transported into the 1940s with a modest atmosphere with glass brick columns, high ceilings with old whirling fans and a few splashes of Asian decor. The best tables were those by a window overlooking Walla Walla's Main Street. The Engs' tagline in newspaper advertisements often read, "With a touch of old China." Indeed, a visitor to the Canton felt as if they had been transported out of Walla Walla to some place far away and in another time.

The Canton's menu featured a variety of noodles, as well as American cuisine such as hamburgers, steaks and chops. A favorite was the pork or chicken noodle served in a large bowl with sliced hardboiled egg, sliced meat and steaming broth; or the Spanish noodle, a Chinese-style soft noodle with a spicy red tomato-based sauce.

In August 1980, Bill Eng decided it was time to retire. He sold the café to Anthony Ng, a thirty-one-year-old who had been raised in Hong Kong. Ng

had been working at the restaurant for Eng. The new owner generally kept the original menu but made a few additions, such as chicken and beef curry, and changed some of the recipes of the original dishes, claiming his version was more "real" and authentic. Unfortunately, the Canton eventually closed for good in July 1983.

In the meantime, after their retirement, Bill and Rose celebrated their fiftieth wedding anniversary. On January 19, 1994, Bill Yew Eng died at his home after living an incredible life filled with spirit and endurance while experiencing the worst and the best of America. He left behind two daughters and three sons.

THERE WERE OTHER NOTABLE EAST Asian families making Walla Walla their home. In the early 1900s, brothers Yuso and Takisaku Shinbo emigrated from Japan to the northwest and eventually settled in Walla Walla. In 1918, they opened the Shinbo Brothers Café and Japanese Curiosity Shop. By 1930, the Shinbos had opened the Imperial Cafe at 119 West Main Street. The Shinbos had built a solid clientele offering a variety of food. Plenty of chop suey came from the Imperial's kitchen, and Sundays featured dinners for fifty cents with choices of steak, chicken, turkey or lamb. Side dishes accompanied the meal serving "snowflake" potatoes. And, of course, there was hot, fresh coffee from the Silex coffee maker.

The attack on Pearl Harbor on December 7, 1941, brought forth more hardships for the Asian communities, as Japanese residents living on the West Coast, and even those who became American citizens, were either forced from their homes to internment camps or saw strict curfews placed on them. In the Walla Walla Valley, the Japanese were not placed in camps but, instead, on curfew. It was with these actions of a curfew that the Shinbos were forced to sell their business.

In 1942, local businessman A.J. Mathison purchased the Imperial Cafe and changed the name to New China Café—along with Harold Jackson, who was the owner of the Corner Cafe. The following Thanksgiving, the New China

Imperial Café advertisement, owner Yuso Shinbo, February 1942. *Courtesy of Joe Drazan, the Bygone Walla Walla Project.*

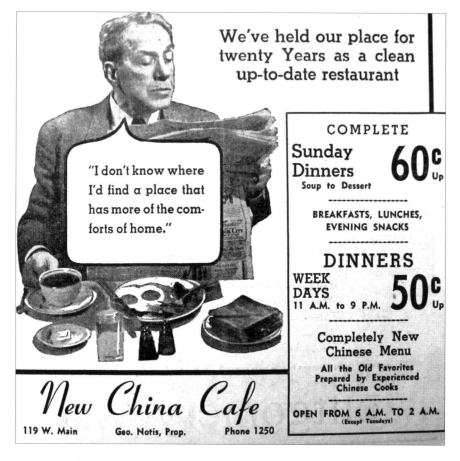

New China Café advertisement, February 1946. *Courtesy of Joe Drazan, the Bygone Walla Walla Project.*

Café went all-out for their diners. For one dollar, customers could feast upon a full course of turkey dinner with all of the fixin's: soups, relishes, ham, filet mignon, "snowflake" potatoes, sweet potatoes, vegetables, fruit salad, sherbet and drink. In 1946, the New China Café was owned by George Notis.

In 1937, the Shinbos celebrated their twentieth anniversary of their curio shop, and in the spring of 1946, the Shinbo Curio Shop was closed. Yuso Shinbo remained in Walla Walla, where he raised his family.

4
Pasta la Vista, Baby

When the moon hits your eye like a big pizza pie, that's amore.
—*Dean Martin*

The migration of Italian families was an important addition to the Walla Walla Valley. Two Italian immigrants who left a significant imprint on the area were Frank Orselli and Pasquale Saturno.

Frank Orselli was born in 1833 in Lucca, Italy. He would find his way to Washington Territory in 1853, the same year the territory was formed. By 1865, he owned 180 acres of land in the original town plat, north of Main Street from Second to Ninth Avenues, near the former Washington Elementary School. Following the family traditions of Italy, Orselli would plant on his farm vegetables, wine grapes and an orchard. The diligent and hardworking Orselli was not only a farmer and a member of the Walla Walla Fire Department but also the owner of the California Bakery located on Main Street and Second Avenue, downtown Walla Walla. The bakery sold not only baked goods but also supplies, groceries, fresh fruits and vegetables, tobacco, liquor and wine. Orselli's was one of the first downtown wine "tasting rooms," and he was also a visionary in large wine production and especially in more affordable wines.

In the early 1870s, Pasquale Saturno left the island of Ischia, a volcanic island in the Tyrrhenian Sea nineteen miles from the city of Naples. His journey to and in the United States took him through New York, Texas, California and finally Washington State. In January 1876, he arrived in

Walla Walla, where he made his home, which has continued to serve five generations of the Saturno-Breen family (Breen was Saturno's American surname).

In the early 1880s, more families arrived from Italy. Saturno, along with another Italian settler, Joseph Tachi, who had also located in the valley, sponsored and paid the fare for other Italian families to join them. Those accepting the fare were given work so they could pay back their passage once they arrived in the Walla Walla Valley. Like Orselli, Pasquale Saturno was a farmer, and the "Saturno-Breen Truck Garden" was the first commercial garden in the valley. As the first commercial grower of Walla Walla Sweet Onions, he was soon named the "Onion Man." He grew row crops of onions, radishes, spinach and other vegetables that he could distribute to produce houses, to the soldiers at the local Fort Walla Walla and to other members of the community.

Many local Italian families would continue their Old World tradition of making wine, therefore making arrangements with their out-of-town friends and family members to send them tons of grapes, usually Zinfandel, by railcar from California with delivery to Seattle and, of course, Walla Walla. Later, with the assistance of the Walla Walla Gardeners' Association, founded in 1916, included in those railcars were Italian groceries, such as pasta, spices, canned Italian tomatoes and other specialty items that were often used for special family occasions and holidays.

The Walla Walla Gardeners' Association, a local produce-packing and shipping company, was founded as a cooperative for local farmers to pack and ship their local produce. Unfortunately, the Walla Walla Gardeners' Association, after an almost one-hundred-year history, closed its doors on November 19, 2012.

EUGENIO "GENO" DELUCA CAME TO New York from Calabria, Italy, in 1920 and five years later made his home in Walla Walla. Like many Italian settlers before him, he started a truck garden, where he raised and sold a vast assortment of produce, including asparagus, beets, carrots, potatoes and turnips. What he couldn't raise, he purchased from California and sold around the Northwest. After thirteen years of farming, he became co-owner of Liberty Cigar Store on 223 West Main Street. Two years after the purchase of the store, DeLuca bought out his partner. DeLuca would later recall that the little tavern was a gathering place hosting pool and card games, and he would also make notice of how the times were so different

in that era, as the signage on the front door of the Liberty Cigar Store said, "No Women Allowed."

DeLuca's entrepreneurship would continue. In September 1955, he and business partner Patrick Cunningham purchased the Villa on the corner of Ninth and Main Street from owners Ida Scroggin and Edith Connal. The new partners closed the restaurant, and the building took on a remodel. In January 1957, the "new" Villa reopened featuring cocktails to be served in the Fiesta Room with a wall-sized mural of Venice in tones of gray and black and white accents. The walls of the new dining area, known as the Gondola Room, were painted in soft pink with dining tables topped in pink Formica with gray accents.

The partners brought in an Italian chef from Portland, Oregon, and a new "charcoal broiler" was added to the kitchen. On September 14, 1960, DeLuca sold the Villa. The new business would become the Heidelberg Villa—the menu changed from spaghetti to sauerbraten. But the sale of his business didn't stop DeLuca from working.

He still owned the Liberty Cigar Store, so in 1963, he remodeled the tavern and reopened it as DeLuca's, serving Italian fare and steaks. The old building had been the former Marshall Hotel, and in August 1969, the building itself took on a huge remodel with the removal of the top two stories—it was literally "topped." Also, a side entrance was added facing Fifth Avenue for easier access to the parking lot on the corner of Fifth Avenue and Main Street after the former Odd Fellows Lodge building (1888) was razed in 1968. (The Odd Fellows Lodge was relocated to Alder Street and, once again, to the former YMCA on Spokane Street.) Today, the topped building and the side entrance remain.

When it came to pizza pie, DeLuca had his own thoughts about the American version. In fact, he wouldn't eat it, so in 1975 DeLuca created his own version using generous ingredients and, of course, a "secret sauce," and he added his own special Italian touch. Producing twenty-five hundred pizzas a week in the back of his restaurant, DeLuca went on to sell his Italian pies in nine markets within Walla Walla and the surrounding Tri-City area, including chain grocery stores Albertsons and Safeway.

It was time to slow down. DeLuca offered the business to all three of his sons who, at the time, were in their late forties and fifties. Having seen their father work very hard and keep such long hours, the sons declined their father's offer. In 1984, DeLuca and his business partner sold the restaurant to local Dominic Ferraro. In March 1987, DeLuca's Italian restaurant closed its doors. It was later purchased from Ferraro and opened as a Chinese

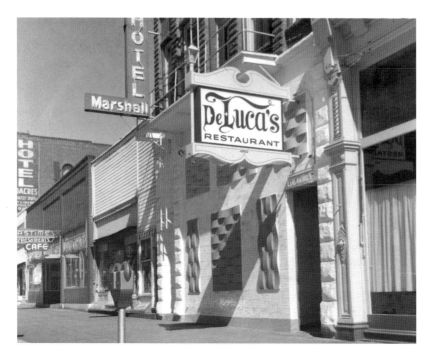

Deluca's Restaurant, with the former top story of the old Marshall Hotel. *Photo by Bill Lilley, 1965, and courtesy of Joe Drazan, the Bygone Walla Walla Project.*

Eugenio DeLuca at the Villa Café, 628 West Main, November 1959. *Courtesy of Joe Drazan, the Bygone Walla Walla Project.*

American restaurant. At the time of the sale, Eugenio "Geno" DeLuca was in his early eighties and claimed he would never retire. Sadly, a year later, he "retired" in peace after such a noteworthy career.

THE CHICKENS CAME TO ROOST—OR, rather, the roosting chickens were turned into cacciatore—at Gallo's Roost at 13 Boyer. Nick R. Gallo opened the Roost in 1954, specializing in traditional Italian American fare such as spaghetti, lasagna, meatballs, dinner steaks, broiled sandwiches and chicken cacciatore. Gallo's Roost fed the lunch crowd and stayed open for dinner until 9:00 p.m.

In October 1960, Nick sold the Roost to his brother Tony and sister in-law. The following year, the business went up for sale and flew the coop.

HE WAS KNOWN AS THE "Magpie" to his staff because they could hear him "squawking" all over the restaurant. He was also known for a few fast holes on the golf course almost every morning, rain or shine, where he would make a quick jump out of the golf cart or practically hang on from the moving cart to take a swing. He was also known for his distinguished Gatsby-style cap that seemed to never leave his crown. But most of all, he was known for bringing pizza to Walla Walla.

Geraldo Leo Magnoni, fondly known as "Jerry Manuel," was born and raised in the Walla Walla Valley. In September 1961, Pizza Pete, a Seattle-based franchise, was advertising in the local paper for potential owners to become a part of their fast-growing chain. It was advertised as more than a pizzeria—a new restaurant concept. An investment of $5,000 would seal the franchise deal. Shortly after the ad appeared, in 1962, Jerry Manuel, along with his business partner Ed Chadek, would have themselves a restaurant. Pizza Pete was first located at 311 South Ninth Avenue. It offered fifty-two different items available as pizza toppings, including shrimp, and offered hours on the weekends as late as 3:00 a.m. for after-midnight snacks.

In November 1968, a new structure was built for this popular pizza place at 1533 East Isaacs. One side of the building offered family dining, and the other side was for adult dining offering beer and wine. The center of the over-twenty-one dining area featured a contemporary-style gas fireplace with seating around it. The ambiance from the fire was perfect for couples looking for a little romance over a glass of vino.

Manuel's motto when it came to pizza was "getting it [toppings] to the edge." Not only was generously topped pizza on the menu, but also an assortment of sandwiches: the Pudgy Pete (a cheeseburger on a well-toasted sesame-seed bun), the Sinker (meatball), strombolis and hot submarines.

The Super Salad was a feast, with chunks of crunchy iceberg lettuce covered with an assortment of cured meats and shrimp and topped with black olives, croutons and a generous amount of shredded cheese. A shrimp salad was offered, and also on the menu was a modest-sized dinner salad of iceberg lettuce with a sprinkling of croutons, a few slices of olives and a choice of dressing, topped with mounds of finely shredded cheese—"to the edge." It was a popular order for the high school girl who wanted to appear as a dainty eater, especially while on a date.

Walla Walla local Jeff Waetje remembers working at Pizza Pete in 1971 when he was sixteen years old. Waetje's starting wage was $1.35 an hour working full-time after school, and his hard work paid off. By 1975, Waetje had become manager. He continued to work there until 1980, when he left to help raise a new family.

In 1980, Manuel found that the cost of owning a franchise was becoming too expensive, so he opted out and went rogue—independent. Manuel was able to keep the menu items, as long as he changed their trademarked names. The new name of Walla Walla's original pizza place became Pepe's Pizza. Later, pasta dishes were added: spaghetti, fettuccini, rigatoni, manicotti, cannelloni and even Cajun-style ribs.

Through the years, "Pizza Pete" and "Pepe's Pizza" were seen as sponsors on the back of bowling and Little League baseball shirts. In 1991, Manuel received the Washington State Restaurant Association's Host of the Year award.

After thirty-three years in the pizza business, Jerry Manuel sold the restaurant in December 1995 to Mike and Madeline Tampourlos from Bellevue. A few years later, before the new century, the town of Walla Walla would be saying, "See-YA pizza-ri-A!" The old pizza kitchen went from serving Italian noodles to Chinese noodles. And what happened to Jerry?

Jerry continued to share his enthusiasm and recipes through his popular pizza booth at the local fair, the Walla Walla Frontier Days. This booth assisted in supporting many local Catholic nonprofit organizations. Jerry died in September 2010, and his recipes still remain with the Catholic schools' nonprofit fair booth.

Did you ever wonder why the Pepe's dinner salad you created with chunks of iceberg lettuce, a sprinkling of three small croutons, a few sliced black

olives and topped with mounds of cheese didn't taste quite the same as Pepe's? You were using shredded mozzarella, right? Wrong. The secret to the Pepe's salad was finely shredded provolone cheese.

Jerry's rant, one he'd say a zillion times a day, was to the pizza makers, "You getting it out to the edges?" This became the crew's joke, greeting, etc. They'd see each other on the street and say "You getting it out to the edges?"
—*Jeff Waetje, former manager of Pizza Pete*

THERE WAS A POPULAR TELEVISION commercial back in 1974 for an Old World–style jarred spaghetti sauce. It featured a young son imitating his father by pretending to tweak his mustache after chewing on a mouthful of spaghetti and claiming, "That's Italian!"

In the late summer of 1977, longtime locals Tom Sr. and Fran Maccarone brought to downtown Walla Walla their own version of That's Italian Pasta Shop & Deli. It was located at 121 East Main Street. The shop was open Monday through Saturday with hours from 9:30 a.m. to 5:30 p.m. The deli menu specialized in Italian-style sandwiches and salads. On the shelves was an assortment of Italian groceries: domestic and Italian pasta and cheeses, cured meats, olive oil, spices, imported cookies and other Italian deli items.

One of the popular sandwiches featured meatballs prepared using a family recipe and loaded on a baguette topped with marinara sauce and melted cheese.

In August 1978, That's Italian Pasta Shop & Deli moved to 17 North Second Avenue. In September 1984, Fran announced that That's Italian was closing its doors. Addio deliziose polpette di carne.

LAST, BUT CERTAINLY NOT LEAST, it was a landmark, a weekly institution that the locals could depend on for a cup of coffee; a stiff, hand-poured well drink; a place to cash a paycheck and, most of all, a solid home-style cooked meal. It was the Pastime Café, with its neon signage, including the "spaghetti and meatballs" sign on the front window. The Art Deco decor and the family-friendly atmosphere was a return to the 1930s, no matter the decade, at 215 West Main.

The Fazzari and the Rizzuti families were among the notable Italian settlers who made their home in the Walla Walla Valley. Louie Fazzari

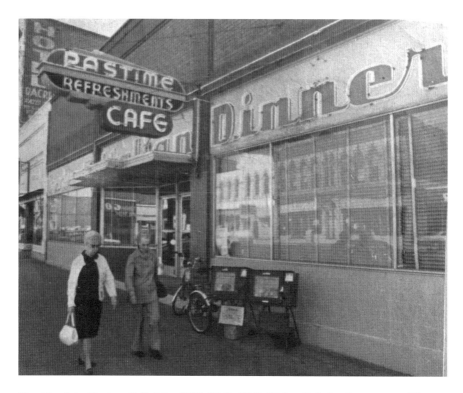

Outside of the Pastime Café, May 1977. Walla Walla Union-Bulletin *photo, courtesy of Joe Drazan, the Bygone Walla Walla Project.*

and Frank Rizzuti arrived in the United States from Italy when they were children with their parents in the early 1900s.

In 1925, Louie Fazzari purchased a cigar store/pool hall by the name of the Pastime with his brother-in-law Sam Mele. At the time, the old cigar store was located on South Fourth Avenue and had originally been owned by two Asian businessmen who settled in Walla Walla. Around 1927, Frank Rizzuti purchased Mele's share of the business, joining Fazzari, and together they moved the cigar store and pool hall to the 215 West Main Street location, selling tobacco, pipes, candy and even ice-cream sodas.

With a small grill and a hot plate, the two partners, often with the help of their wives, found a way to serve food to the pool-playing patrons. Their business grew, and they eventually purchased the Rex Café located next door. This new space already had dining booths, making it ideal to fill the space with more customers. Before they knew it, around 1935, the pool hall was converted to a dining area, and the Fazzari and Rizzuti team had a

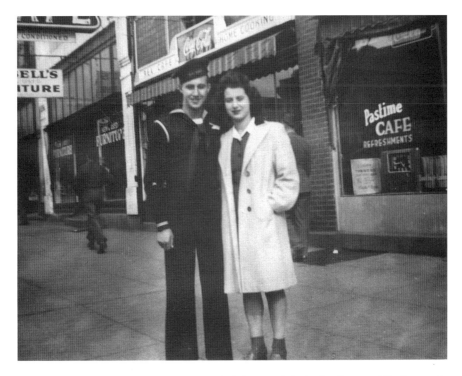

Couple in front of Pastime Café. The Rex Café is to the left, 1940s. *Courtesy of Joe Drazan, the Bygone Walla Walla Project.*

restaurant serving affordable Italian and American food to families and the working class.

The popularity of the restaurant was another reason to expand, and in July 1955, the Pastime added its new Venetian Room, a formal dining area seating one hundred extra people. The new room included three extra-large booths, a wall mural of Venice and another smaller dining room in the back for private parties.

Through the years, the Pastime would open as early as 5:30 a.m. with breakfast seating in the old dimly lit bar with "girlie" pinups on the wall. Also featured were pool and a few quiet games of cards. Many old-timers would heed warnings to women, "That bar ain't meant for the ladies."

Transients and locals looking for work often sat in front of the building while waiting for a farmer to drop by looking for a work crew. Those interested in a good day's work for some quick cash and a meal would hop in the back of the farmer's pickup and head out for a day in the

Louis Fazzari at cash register at Pastime Café, March 30, 1969. *Walla Walla Union-Bulletin photo, courtesy of Joe Drazan, the Bygone Walla Walla Project.*

fields. Attorneys and jurors from the courthouse next door could depend on a coffee break or a good meal during court recess. Funeral directors dressed in their dark suits and ties would stop by the bar before sunrise for a quick breakfast and a cup of coffee. A doctor stopping by the bar for a quick no-frill sandwich may be sitting next to a homeless man sipping on a free bowl of soup and a cup of coffee. And Saturday evenings in the Venetian Room would find families coming back from Saturday evening Mass at Saint Patrick's Church, which was just a quick one-block walk to the Pastime.

As their success continued, Fazzari eventually retired in 1959—or so he said. Grandfather Louie Fazzari sat vigil for years minding the till, selling cigars to the adults and handing out candy mints to the patrons' children. Frank Rizzuti retired shortly after and died in March 1976. Louie died shortly after his ninetieth birthday in January 1983.

Louie's son Frank Fazzari continued to walk in the path of his father and started working behind the Pastime's candy counter when he was fifteen years old. Frank soon became the face of the Pastime for many decades, always noticeable in his bright white shirt and white apron tied around his waist. It seemed as if the only time Frank wasn't in his daily uniform of white was when he was at church or attending a relative's funeral. Once labeled as "part workhorse and part social butterfly," Frank could be depended on by diners, whether he was behind the bar serving drinks, cleaning and setting tables, visiting with his guests or visible through the kitchen's service window bringing orders to the front for pickup. Frank was a fixture that the community who entered through the doors of the Pastime could depend on. Frank would make things right.

Not only was Frank a fixture, but so were many of the staff members. Rose Marie "Rosie" Basta was in the Pastime kitchen for around fifty years, every day before sunrise, making her special red sauce and daily house-made soups, and she hand-rolled every generous-sized meatball. After Rosie

retired, Craig Arland continued to make Rosie's "secret" sauce until the last evening of service. Craig had been working for the Fazzari family since he was twelve years old, and on that pivotal last night of the Pastime, he clocked out with thirty years of service. Bertha Lesser no doubt had a collection of interesting tales after tending the bar for thirty-two years. Ivalee Wilson waited tables for thirty years, along with many other dedicated Pastime staff. Through the years, many patrons were also met by Virginia Fazzari, Frank's wife, who would quietly and graciously lead her dinner guests to their table or favorite booth.

There were no surprises at the Pastime. You could visit once every ten years and see the same establishment. It was dependable. You knew the waitress and the busboy, and the meal was always consistent.

The most popular Italian-inspired dish was the house lasagna. Many locals knew exactly what to expect, while the newbie tourist to the diner would be surprised that it wasn't the traditional layered square of "fancy-schmancy" lasagna they were used to. Instead, the Pastime lasagna was served on an old metal steak-serving platter piled generously with wide egg noodles topped with Rosie's special red sauce, loaded with lots of cheese and then presented to the diner while the cheese was still hot and bubbling. A diner could order a plate of lasagna, spaghetti or ravioli generously covered with red sauce via

Rose Marie "Rosie" Basta in the kitchen at the Pastime Café, December 1, 1991. Walla Walla Union-Bulletin *photo by Greg Lehman, courtesy of Joe Drazan, the Bygone Walla Walla Project.*

solo or select from an addition of sides with which to adorn their plate of pasta: large hand-rolled meatballs, "peppy" Italian sausage, fried pepperoni, fried salami, large breaded fried shrimp or a couple of pieces of crunchy fried chicken.

As a third-generation Italian, part-time truck gardener and Pastime regular explained it, the Pastime's lasagna reminded him of what his mother served. He referred to it as "farm food." Italian provisions such as traditional lasagna noodles and imported cheeses were difficult to find in the Walla Walla markets in the early twentieth century. From the 1920s to the 1940s, one couldn't just stroll down to the neighborhood corner market and expect to pick up a tub of ricotta cheese and a bunch of fresh basil. Perhaps once or twice a year, during Easter and Christmas, the local Italian community might receive imports from the Old World via train. In the meantime, they made do with what they could find in the local markets. Nonetheless, the Pastime's version of lasagna was delicious and satisfying.

Some of the other favorite dishes were traditional spaghetti and meatballs and a pan-fried steak with a side of spaghetti. Sometimes, just a plate of plain spaghetti covered generously with butter and parmesan cheese hit the spot. Dinners always included a bowl of tossed salad with iceberg lettuce as the main ingredient and a plate with slices of soft French bread and pats of butter for everyone at the table. Also on the menu were workingman meals like liver and onions and fried egg or fried salami sandwiches. If you just wanted a cheeseburger, fries and a traditional milkshake, the kitchen could serve it up. The milkshakes were presented in beautiful old parfait glasses filled to the top with your favorite flavor of shake; on the side was the rest of the generous amount of milkshake still in the metal container it had been blended in, right from the old green shake machine.

Frank and Virginia's son Robert "Bobby" joined the restaurant when he was twelve years old, and he of course would grow up around the Pastime crew, which also included his brother, three sisters, cousins, aunts and uncles, who had all worked at the Pastime at some point in their lives. On February 6, 2002, at the age of eighty-three, Walla Walla's favorite longtime restaurateur Frank Fazzari died. Bobby would continue to walk the Pastime path his grandfather and father did before him. And, like his dad, Bobby would make sure his customers made it home safe, even if it meant he had to walk them home.

As Walla Walla began a new chapter in the twenty-first century—more like a return to the days when it was founded—the reborn town was filled with new restaurant entrepreneurship and a return to its wine industry.

Left: The old clock was an important fixture in the Pastime Café and remained after Passatempo Taverna opened in the former café space. *Photo by Dee Cusick, Walla Walla.*

Below: The El Katif Shriners in a parade in front of the Pastime Café. *Photo by Jean Cline, 1984, and courtesy of Joe Drazan, the Bygone Walla Walla Project.*

Therefore, competition made a slight dent in the Pastime's daily routine. In addition, there was a purchase proposal on the table. At the beginning of the New Year, the Fazzari family under the management of Bobby announced that the closing of the Pastime would be January 22, 2006.

The evening the Pastime closed its doors for the last time, many locals went to enjoy their final and most memorable dishes from the old kitchen. They visited with their favorite waitress, who had watched the younger diners grow up. There were locals who knew they wouldn't be able to get

through their meal without shedding tears, so they simply relived their memories at home.

Three generations of Fazzaris since 1927 had opened their restaurant doors to the public for almost eighty years. The people who entered though the doors of the Pastime Café never left hungry—not even the man who entered without a penny in his pocket.

Bobby was fifty years old when the Pastime closed. Today, he is consulting about food service for nonprofit and fundraising dinner events.

A man who's down and out and needs a bowl of soup and a burger—of course we'll give it to him.
—Robert "Bobby" Fazzari, January 26, 2007, Walla Walla Union Bulletin

5

A Family Affair

The other night I ate at a real nice family restaurant.
Every table had an argument going.
—George Carlin

In the last century around the nation, especially noticed by many who grew up in Walla Walla, dining establishments and other businesses were typically not open on Sundays. It was a day of rest for many, a time to focus on family, often a school night for the youngsters and, most of all, time for Sunday dinner—at home.

Afternoon or early evening meals covered both lunch and dinner. It was just a good reason to bring several generations of family and friends together.

In 1909 in Washington State, the "Blue Law"—also known as the "Sabbath Breaking" law—was enacted and strictly enforced. This law meant there would be no sale of liquor or any alcohol products like beer and wine on Sundays. It also prohibited restaurants across the state from selling liquor. For many, it was a good reason to close on Sunday, especially if liquor was a large part of their profit. Some grocery markets even kept the beer and wine covered from the hours when the bars and taverns closed at 2:00 a.m. Sunday morning until Sunday noon, when church got out.

On November 8, 1966, voters adopted Initiative 229, repealing the Blue Law. There were a few more legal hurdles to jump through in subsequent years, but, ultimately, this action eventually led to the sale of liquor on Sunday.

THE KANDYLAND CAFÉ WAS KNOWN as the "sweetest shop in town." Opened in 1917 by owner Frank Robinson, this café and confectionery advertised its address at 23 East Main Street and was known as the first confectionery in Walla Walla. A year later, the new owner, Jesse Keyes, moved his business to 22 East Main. Keyes served breakfast at 6:00 a.m. and continued service through lunch and finally ended the evenings with dinner, closing as late as midnight. In keeping with a family atmosphere, no wine or beer was served. It advertised itself as a "clean and bright place to bring the family" with "deft" service.

The confectionery part of their café was located in the front of their shop, and the café was in the back. The popular "Blue Plate" special lunch was served in the back of the house and consisted of meat, potatoes, vegetables, dessert and coffee—all for seventy-five cents. The Keyes employed at least eight waitresses and cooks. Most of all, their confectioner, Ed "Candy" Gross, was a vital part of the "sweet" operation. Among the sweeter treats that Jesse and his wife, Ella Henrietta, offered were the special whipped cream chocolates and whipped cream pie—"large, thick portions piled high with real whipped cream."

Around 1923, Jesse and Ella changed the name of their business to reference their family surname, Keyes Confectionery and Restaurant. Their confectionery was known all over the Northwest, and they shipped

The Kandyland Café on Main Street featuring sweets and soda, 1919. *Courtesy of Joe Drazan, the Bygone Walla Walla Project.*

their chocolates all over the world. Chocolates weren't their only sweet, as Ed Gross also produced ice cream and "frozen ice" (sherbet). Later advertisements around the 1940s showed that the restaurant was located at 216 East Main.

Keyes Restaurant took on new management on March 13, 1949. The business would slowly fade into the candy-colored sunset.

Jesse and Ella would resume with active lives until Jesse died in 1965. Ella died much later, in 1990. They would leave behind generations who still reside in Walla Walla: their grandchildren and their children.

You could open a box of chocolate-dipped candy and my Grandmother could tell you what the center was in each piece by the decorative universal "squiggle" code on top.
—Patty Keyes, granddaughter

A few years later at the same location, the Copper Kettle restaurant, named after the copper kettles used in candy making, opened in May 1947 at the 22 East Main address. There would be many managers and owners, and a few remodels would take place at the Copper Kettle restaurant until its copper, well, tarnished.

In the meantime, the last address of Keyes Restaurant at 216 East Main just seemed to be made for sweet treats. On December 8, 1951, the Spudnut Shop held a grand opening with local Norman Anderson as owner-operator. Spudnuts was a trademarked franchise from Salt Lake City with stores from coast to coast and from Alaska to Mexico.

A spudnut is a yeast doughnut made with wheat flour and dehydrated potatoes. After baking, this treat would be glazed, sugar-coated or iced with chocolate frosting. Spudnut also offered a variety of "spud" pastries like Bismarks, Button and Bows (a jelly-filled doughnut shaped like a bow), Spuddies (doughnut "holes") and the Spud-Over, an apple-like turnover. Later advertisements in 1956 announced that Walla Walla's Spudnut was serving pizza pies.

In September 1961, Norman Anderson announced that he had sold the Spudnuts franchise to local Clayton Young, who had previously worked at Spudnut in Utah. The new Spudnut opened in September 1961 at 110 South Ninth Avenue with Young and another local, Daniel Boule. Besides selling Spudnuts retail, they also sold this potato pastry delicacy wholesale. At the time of the opening, there were thirty-seven Spudnut shops around the country. Today, the closest Spudnut Shop

remains in nearby Richland, Washington, which is just a short sixty-mile drive from Walla Walla. The Richland Spudnut is also known as the oldest coffeehouse in the area.

In the meantime, Norman Anderson remained at 216 East Main, and the location was soon known as the Hi-Spot, where the little diner served pizza pies, lunch and foundation specials—and even an occasional Spudnut.

Joseph "Joe" Denney purchased the Hi-Spot on April 10, 1963, and changed the name to Denney's Hi-Spot. Twenty years later, Joe sold the popular drop-in spot when he retired in June 1983.

The morning audience of local radio station KTEL would soon discover that Joe was a singer. Many parents and grandparents looked forward to Joe's morning croons with the piano accompanist; on the other hand, the disgruntled teenager waking up to the song with her parents reminding their student to get to school on time—not so much.

In Joe's best barbershop quartet style of voice, he would belt out the 1967 hit *Walkin' in the Sunshine* by singer-songwriter Roger Miller, but with a few clever changes to the lyrics. After his song, Joe would continue to remind his audiences about the pancakes, merchant lunches and the good "cuppa" coffee served at Denney's Hi-Spot.

Walkin' in the sunshine, sing a little sunshine song
Walkin' up Main Street, appetite a mile long
Talk about the good food, talk about the coffee
Talk about the good times, the fun at Denney's
Walkin' in the sunshine, sing a little sunshine song

THE MIDWAY AT THE CORNER of Main and Palouse Streets had quite a variety of menus through its years. In 1917, it made and served chicken "hot" tamales for twenty-five cents apiece. It was later known for fried chicken with "lady cooks" in the kitchen and "girl waitresses." In the late 1920s, Dorothy Harrison was one of the many owners through the years, but the Midway would be known as one of the most popular places to dine—and one of the most beautiful. The popular corner diner also had special dinners for sixty cents, offering choices of turkey, oysters, ham, steaks, fried chicken and lamb chops—just a few of the offerings, and that doesn't include all of the sides and desserts.

By 1929, the Midway was known as the New Midway confectioners and fountain lunch, selling chocolates in beautiful boxes—from tamales to boxes

of chocolates. Let's just say the Midway had a difficult time deciding what it wanted to be when it grew up.

The Midway later featured drugs, toiletries and "courtesy phones," as well as continuing its food service. Long story short, by the 1950s, the Midway became the Thrifty Drug with owner Frank LeRoux.

THE HOTEL WAS CALLED THE Pollyanna, and chances are pretty good that around 1916, there weren't a lot of "Pollyannas" who were guests—more like workers for the many new building projects that existed around the birth of the town. And the workers had to eat, right?

Mrs. Anna Gertrude Hollister had the solution and opened up the Pollyanna Cafeteria at the hotel located at 11 East Alder, where you could get a "dandy lunch for only 25 cents." In the early 1920s, Claude Henline purchased the restaurant and moved it across the street from the hotel at 9 East Alder and eventually moved it to 31 East Main, changing the name to the Pollyanna Café. The restaurant was advertised as "the only restaurant on Main St. where a black man could eat."

Left: Pollyanna Cafeteria business card; *Below*: The Pollyanna, with Floyd and Marie Henlines, 1940s. *Photo republished by* Walla Walla Union-Bulletin *in 1999. Courtesy of Joe Drazan, the Bygone Walla Walla Project.*

In 1945, Claude's son and daughter in-law, Floyd and Marie Henline, took over the café, and it became a favorite lunch and dinner spot for the locals. The Pollyanna Café and Fountain featured sandwiches, soups, fish and chips and steaks. They prepared their own mayonnaise and salad dressings from scratch and baked their own house-made dinner rolls, pies and cakes. One of their biggest advertising features was to announce they had air-conditioning, which was rare in the 1940s.

At the end of the year in 1966, the Henlines announced it was time for them to retire, and the fifty-year-old Pollyanna namesake closed on December 29. The Henlines would later come out of retirement just long enough to get their son Bryce started on his own restaurant venture, a third generation in the business.

"TAKE ALL YOU WANT. EAT all you take" read the sign attached near the cash register as a reminder for those whose eyes were bigger than their bellies. Roy's Chuckwagon was a family pleaser, as it fed hungry teenagers, picky children, moms wanting a break from the kitchen and dads needing to make everyone happy while following a budget.

The owner and founder of this popular western-style smorgasbord, Roy Weisenberger, opened his Walla Walla restaurant in 1967. This wouldn't be the first or the last restaurant that carried his name. Roy was known for the Chuckwagon, but also around the Northwest were Roy's Western Smorgy and Roy's Pancake Coral. The location was known by the locals as the "Big Y" shopping center, due to a fork in the road on Rose Street and the exit to Wallula Road. The space had previously held McGee's Café.

The all-you-can-eat hot entrées changed almost daily, but always consistent was the cold table with a variety of salads like macaroni and potato and sides such as Jell-O, cottage cheese and vegetable garnishes. Baron of beef, ham and chicken were offered various days of the week. Of course, fish on Friday evenings was popular with those keeping their holy observance of abstaining from meat on that day. The menu included fried fish, prawns, oysters and sometimes crab legs; for the kids, there were many desserts to choose from.

Roy understood families and how youngsters dined, so children's prices depended on their age: ten cents per year up to the age of ten; a ten-year-old could eat for a buck. Then there was the kid who was eight years old who looked like a five-year-old and ate like a ten-year-old.

McGee's at the Big Y Shopping Center, September 19, 1960. *Courtesy of Joe Drazan, the Bygone Walla Walla Project.*

In 1984, Roy's manager, Floyd Harris, died. After a few rocky years with different managers, the business eventually was put up for sale, but with no takers. Walla Walla's Roy's Chuckwagon equipment was auctioned to the highest bidder on July 13, 1987. "Wagons! Onward ho!"

IN 1968, A NEW STRUCTURE was built on the corner of 201 East Main Street. The retro-style building named Fancy Dan's was a bit obvious compared to some of the grand structures from the early 1900s. The new building cost $44,000 with a $3,600 parking lot.

The founder of this new project was Ron Berquist, an Oregon native who had other Fancy Dan's stores in five Oregon locations, including Portland.

Fancy Dan's featured a full dining room and coffee shop. The menu was designed to fit with a family restaurant. The establishment was open twenty-four hours a day serving sandwiches and steak dinners, omelets and pancakes.

Besides catching a bite to eat, Fancy Dan's was also the place to grab a late-night cup of coffee and a slice of pie to fuel a study session or just some studying of human behavior—people-watching. Let's put it this way: some of the customers didn't behave very "fancy" at Fancy Dan's.

fancy dan's restaurant

The Exciting Dining Place

The "New"
GRANADA ROOM
We invite you to visit our new
Granada Room for cocktails,
dinner or just plain relaxing.

The New Redecorated
Dining Room
Where you can enjoy your
evening meal in comfort and
luxurious surroundings. Banquet
for 15 to 40 by reservation.

Where Delicious Food Is Served 24 Hours a Day

Fancy Dan's Restaurant and
Granada Room, February
1972. *Courtesy of Joe Drazan, the
Bygone Walla Walla Project.*

In 1978, Berquist founded the Shari's restaurant chain, with the first store in Hermiston, Oregon, fifty-five miles from Walla Walla. In 1979, the Walla Walla Fancy Dan's closed. Berquist would continue with the Shari's chain, and by 1999, Shari's was the ninth-largest family restaurant chain in the United States. There is currently a Shari's in Walla Walla on Ninth Avenue and Chestnut Street.

THE LOGO WAS A PLUMP, short, friendly friar familiar from the Robin Hood stories. In this case, the bald-headed, robe-wearing friar was holding a chicken leg. It was a clever play on words: a friar holding the leg of a fryer.

In the summer of 1974, brothers LaVerne and John Johnson opened up Fryer Tucks Pioneer Pantry, a family restaurant located at 2251 East Isaacs Avenue. This address had been the earlier home to Lytles Café. Both of the Johnson brothers had been involved as managers of the well-known Kentucky Fried Chicken joints. This time, instead of a colonel, their friendly frying friar was known for fried chicken and English-style fish-and-chips. The restaurant served breakfast, lunch and "supper." Every chicken or fish special meal included Little John spuds, special spud dip, coleslaw and a roll. Fryer Tucks later expanded its menu to include potato and macaroni salads, baked beans and pie.

There were often incentives to drop by Fryer Tucks for dinner. If you purchased a new tire from its neighbors at Firestone Tires, Fryer Tucks might even give you a free chicken dinner. If you bought four tires, well, you got a complete chicken dinner for the whole family. New tires and fried chicken—how could you go wrong?

In August 1976, Fryer Tucks closed its doors but hopped back into business in April 1977. However, this time it opened without the Johnson brothers. The business would take on a new name, a new owner, a new location and a new manager. The Friendly Fryer's new owner was Jerry Manuel, known for serving up pizza, with LaVerne's wife, Evelyn, as the manager.

The new location was at Ninth and Alder Streets, a busy spot that had previously been the home of the Arctic Circle Drive-In. The ghost of the old hamburger drive-in must have been sending vibes to the Friendly Fryer, as it added a huge hamburger to the menu that was six inches in diameter. The new burger, known as the "Walla Whopper," was topped with a special sauce, lettuce and pickles. The Fryer later offered fish and chips, reminding the observant that "Friday was Fish Day!" Beginning at the end of 1978, we never heard another peep out of the Friendly Fryer.

As soon as you walked into the Eastgate Mall, you caught the fragrance of fresh-baked cinnamon rolls, bread pudding and cookies. This corner nook by one of the main mall entrances, known as the Breadboard, was a sandwich shop with origins in Daly's Drive Ins, Inc. of Seattle. It offered a selection of fresh sandwiches made to order with hearty slices of fresh baked bread, as well as soup, salads and a selection of pastries. Three of its most popular sandwiches were the sliced turkey topped with fresh sprouts, egg salad with slivered almonds and tuna salad with diced water chestnuts.

The sandwich shop was one of more than twenty stores that were a part of the grand opening of the new Eastgate Mall in the fall of 1974. It was, in fact, the first shopping mall to open in Walla Walla. The Breadboard opened with its new manager, Ruth DeFreece, who had previously been manager of the J.J. Newberry Co. Fountain Lunch before the store's closing. She had also been manager of the Southgate Drug Fountain Lunch and the Book Nook Fountain Lunch.

The Breadboard became one of the most popular places in the mall, with sales staff from other stores catching a quick lunch break and shoppers wanting a time-out to savor a sandwich or a cup of coffee before the next round of power shopping.

As the Eastgate Mall went through new property managers and rent increases, shops started vacating. By the late 1980s, the Breadboard packed up as well, without leaving a crumb behind.

Take one funeral director, one insurance salesman and one vacant 1920s gas station, mix in a really savory sauce, and you have Philies. William E. Walker and Jeffrey T. Menzel were looking for something to supplement their income as well as to take a vacation from their professional jobs.

A family member had talked about a cheesesteak sandwich they had ordered at a restaurant in Pennsylvania. The defining element of that sandwich wasn't the steak, white American cheese, onions and peppers, and it wasn't even the roll. It was a special sauce unique to a traditional Philly cheesesteak. The red sauce wasn't an Italian-style sauce, and it wasn't a hot sauce. It just so happened that a family member had the recipe that the owner of the Pennsylvania restaurant shared with him. Several batches of sauce and a few sandwiches were flown in directly from Pennsylvania, and Walla Walla's version of the Philies cheesesteak sandwich was born.

Philies opened in December 1983 at 115 South Third Avenue. After removing three tons of building rubbish, the partners remodeled an old gas station that had been vacant for years and turned the garage portion of the building into a dining area. The look inside the little diner was retro, from the black-and-white floor tile to the Coca-Cola memorabilia on the walls. The menu was simple. They had followed the advice of a local businessman: "KISS—Keep It Simple, Stupid." And they did, serving only five items. A choice of three sandwiches was offered: the traditional Philies cheesesteak; the Philie Dog (the same sandwich, but instead of shredded grilled steak, it was a foot-long hot dog); and, later, the Bluto Burger, a rather large double burger that was a tribute to John Belushi's role in the movie *Animal House,* one of Walker's favorite movies.

Philies also offered sides of curly fries and a hearty, fresh dinner salad. In fact, Philies was the first restaurant to offer curly fries in the Walla Walla area. It originally purchased a manual curly fry slicer, cutting pounds of potatoes by hand, until a regional wholesale food vendor brought frozen curly fries to the restaurant market. What the owners didn't expect was customers asking for sides of Philies sauce for dipping curly fries.

Later, Philies opened for breakfast, serving traditional choices, but its biggest hit was the Philies omelet, with shredded beef, grilled onions and peppers, cheese and the Philies sauce drizzled on top.

Three years after its Walla Walla opening, Philies expanded with a second restaurant in Mill Creek, Washington. After many hours behind the grill and with young families at home, the owners' professions were calling them back to their office jobs. Philies made the last of that special savory sandwich sauce for the public in 1988.

One of the owners commented that, many years later, they would still receive phone calls from locals asking for the "secret" steak sauce recipe. Even a few business people in town asked for the recipe, of course always

promising to "make it for only home use." While Walker and Menzel no longer live in the area, the legend is that the Philies steak sauce formula still exists in an old copper recipe box somewhere in the valley.

Indeed, it was "Something Different," and it was so refreshing to have choices of takeout other than burgers and pizza. Owner Angie Lindberg, along with the help of her husband, Curt, was ahead of her time. Her goal was to offer fast-food takeout but serve wholesome, home-style food. Something Different was located at 420 South Ninth Avenue in September 1986. About thirty years before, the little corner spot had been the home of Wolfson's Drive-In. The little building that faced Chestnut Avenue at the busy intersection is no longer in existence.

Some of the choices on the menu, with the help of Angie's sister, chief cook Connie Snell, were the following: lasagna, barbecue chicken, stroganoff, stuffed peppers, cabbage rolls and pineapple chicken, as well as salad and house-made dinner rolls. One of the popular meals was runza, a traditional German and, later, midwestern yeast dough bread pocket that was about eight inches long and generously filled with ground beef, seasonings, cabbage and onions. What was for dessert? Pies with fillings that weren't always available at other stores and bakeries, such as strawberry or pineapple.

Angie's fast-food concept was perfect for professional people who didn't break for lunch or for parents too tired to cook after a long day. Customers could drop by Something Different or make a phone call and even ask for delivery service via Curt and his Ford Escort station wagon. A hungry and anxious customer could be guaranteed a meal just like "mom used to make" in portions for individuals and families.

In the fall of 1994, several area businesses were being burgled, often with attempted arson. Something Different was one of those unfortunate businesses. It was struck on the morning of November 25 with estimated damages of between $15,000 and $20,000. Shortly after enduring such hardships, the little business wrapped it up.

In 2008, there was no longer "home, home on the range" at 1528 East Isaacs. The Homestead Restaurant had been a standard for twenty-seven years. Chef Clark Covey was faced with closing his doors when the landlord informed him that a new pasta bistro, Wang Wong, was replacing him.

The atmosphere of the Homestead was "homey," with a lot of oak surfaces, vintage-style farmhouse print wallpaper, niches and shadow boxes displaying vignettes of old clothbound books, pretty china plates and dainty silver spoons. It lent itself to making memories. Many locals would celebrate birthdays and anniversaries there, with family gathered around large oak dining-room tables in the center of the room. The booths surrounding the dining area were ideal for romance, especially on Valentine's Day. Heart-shaped boxes of chocolates and flowers, as well as a complimentary photo, were given to the couples by management.

The chef and his staff served well-executed plates that were always fresh and consistent: filet mignon, prime rib, fresh seafood, pasta, seasonal fresh vegetables and the best crab cakes topped with a French beurre blanc sauce. A loaf of freshly baked bread was placed at the table, and if you didn't eat all of the bread, you might have room when the cart of beautiful desserts was brought around. Lunch and Sunday breakfasts were also available, but it was always best to go before "the church crowd."

There wasn't a lounge, but that didn't stop the servers from dropping off the requested martini with two olives or the wine list featuring many local wines.

Let's just say that, in Walla Walla, the Wang Wong wasn't so well received. The Homestead Restaurant might still be around....

ENJOY a FAMILY ADVENTURE...make it a perfect day, take the family and relax in the friendly atmosphere of one of the many area restaurants represented on this page. Make your plans now for you and yours...and be sure to include the children. Nothing teaches a child more of how to act in public than taking them with you. All the fine restaurants, represented will please you with fine food and good service and reward you for your day of hard work and change it to one of relaxation and fun for the entire family.
—*October Restaurant Month ad in the* Walla Walla Union-Bulletin, *October 19, 1969*

6
Out to Lunch

Sandwiches are wonderful. You don't need a spoon or a plate!
—Paul Lynde

Blue Plate Special, club sandwich, tuna melt, BLT, ham salad sandwich, hot roast beef sandwich, Shrimp Louie, pie à la mode, ice cream soda, malted shake and the bottomless 5-cent Cuppa Joe.

Luncheonettes, lunch counters and fountain lunches were typically found in plush department stores and especially in five-and-dime stores starting as early as the first decade of the 1900s. They were convenient, friendly on the pocketbook and customer service–oriented with the wait staff always within a few feet, like the friendly bartender. Not only were these counters handy for the shopper, but they also helped the business keep its customers in the store—a captive audience. Hey, the hungry shopper had to eat, right? Why send her someplace else?

It was around 1937 when J.J. Newberry Co. opened its doors at 10 East Main Street in downtown Walla Walla. It would continue to operate at this location until opening a newly remodeled and larger building at 116 East Main in November 1955. This structure was one of the restaurant's finer models, and the larger store was a boon to Walla Walla's employment, as a total of 200 people would be employed, from management to custodians. Included in that figure were 150 local "salesgirls."

This new five-and-dime chain store was founded in 1911 in Pennsylvania by John Josiah Newberry, who died a year before Walla Walla opened its new store. The actual concept of the five-and-dime was original to Woolworth's, which first opened its stores in 1879.

Just like the rest of the J.J. Newberry stores across the United States and Canada, the Walla Walla store sold just about everything except groceries. The shelves were lined with a variety of inexpensive personal and household goods, from hair gel to live goldfish and from candy and fresh popcorn to fabric by the yard. And, of course, items such as grilled cheese sandwiches and banana splits were served at the lunch counter.

The stores remained successful for years until the potential demise of the company became apparent when J.J. Newberry Co. filed for Chapter 11 bankruptcy in 1992. In Walla Walla, it became more apparent when Newberry's shut its doors on January 10, 1976. Several Newberry stores closed in 1997, with a few lingering on. The final Newberry's, located in downtown Portland, Oregon, closed in 2001.

Walla Walla saw other chain department store lunch counters. In the 1950s, Idaho's Joe Albertson built an Albertson's Super Center at 416 East Main on the corner of Touchet Street. It was one of the larger stores in the area and featured a lunch counter serving hot chicken and turkey dinners for seventy-nine cents.

The S.S. Kresge Company, later known as K-Mart, was popular around the country for its lunch counters. In later years, around the 1990s, it rebranded its lunch counters as the Eatery Express. In Walla Walla, K-Mart arrived in 1974, and the remodel of its lunch counter to the new Eatery Express appeared in 1992. The lunch counter would eventually close.

S.S. Kresge (and K-Mart) was best known for its bologna or boiled-ham submarine sandwiches. These were served on a soft submarine-shaped roll spread with mustard and topped with slices of American cheese, a few slices of pickles, onions, tomatoes, shredded lettuce and a few slices of banana pepper, washed down with a cherry or blue raspberry ICEE, a frozen slushy drink.

The nation started to see the decline of lunch counters toward the end of the 1970s. They had been an important asset in downtown communities. Strangers, whether office people or teenagers, sat next to each other. Lunch counters were an institution of service and civility and sometimes even the great neutralizer.

Cigar shops were the place for businessmen to relax during their lunch hour and after work. Such places included Kelly's Cigar Shop, Lutcher's Cigar Shop, the Blue Lantern and Shep's Smoke Shop.

The Blue Lantern set up shop at 10 West Main in 1927, selling cigars, tobacco and candy. It offered specialties from its fountain lunch. Its business hours were as early as 6:00 a.m. for breakfast, and it stayed open until midnight serving coffee and a fragrant puff or two off the cigar.

Kelly's Cigar Shop was located on First Avenue at the former First National Bank building on Alder Street. It had been one of the "old-timers," selling cigars, magazines, candy and other tobacco products as far back as the early 1900s.

The original cigar business was started by Canadian-born John H. "Little John" Kelly when he moved to Walla Walla in the 1880s. Locals named him "Little John" to distinguish him from a cousin, John "Big John" Kelly, who was also a local businessman. Kelly managed the Delmonico Hotel across Main Street from the Dacres Hotel, then known as the Stine Hotel until a fire destroyed the Stine building in 1892. James Dacres erected a new hotel in 1899.

Kelly started his business on Main Street between Second and Third Avenues until a new location was constructed at the bank building in 1920. The bank building would later be known as Seattle First National Bank.

First National Bank and Kelly's Cigar Store at Second and Alder Streets. *Courtesy of Joe Drazan, the Bygone Walla Walla Project.*

Advertisement for Kelly's. Note the "Buy Defense Stamps and Bonds" in the lefthand corner, February 1942. *Courtesy of Joe Drazan, the Bygone Walla Walla Project.*

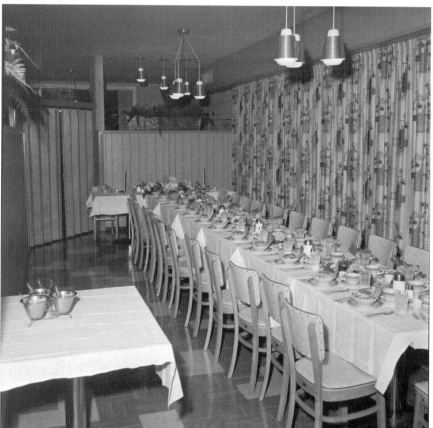

Private party at McGee's Restaurant at Big Y, 800 Northeast Rose Street, October 1962. *Courtesy of Joe Drazan, the Bygone Walla Walla Project.*

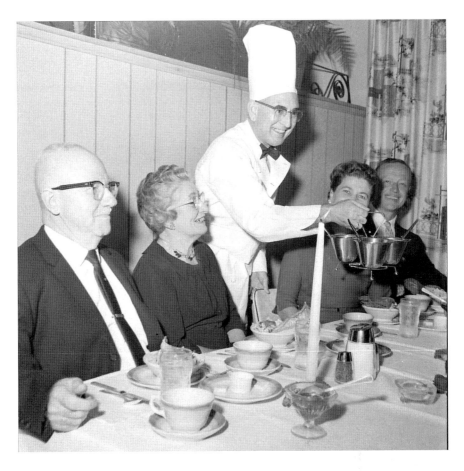

Above: The Cooke private party at McGee's Restaurant at Big Y, October 1962. *Courtesy of Joe Drazan, the Bygone Walla Walla Project.*

Right: McGee's Fountain Lunch advertisement at 1517 East Isaacs with Bill Gulick, local author and historian, February 1952. *Courtesy of Joe Drazan, the Bygone Walla Walla Project.*

In 1938, Kelly remodeled his portion of the building—as well as his business model—by offering breakfast, lunch and dinner and often advertising the house-made pies. And if steak and eggs or a piece of pie wasn't to your liking, there were always drinks and a fine cigar. In 1947, pioneer "Little John" Kelly died at a local hospital at the age of eighty-five.

Shortly after the death of Kelly, Howard and Freda McGee took over management of Kelly's Cigar Store and Fountain Lunch. By the early 1950s, the McGees moved out on their own, opening McGee's Fountain Lunch. Its first location was at the "Big Y." This spot later became the home to Roy's Chuckwagon. The larger location gave the McGees the opportunity to make available private dining.

Shortly after opening at the Big Y at Rose and Wallula Avenues, the McGees settled into their new space at 1517 East Isaacs in March 1951. From 7:00 a.m. until midnight, the McGees served breakfast, lunch, dinner and snacks at the counter or with booth service. By 1963, Mr. McGee retired, closed the diner and moved to Texas.

THE BOOK NOOK FOUNTAIN LUNCH had a history that went back many years throughout the early twentieth century. It was known as the corner nook on Main and First Avenue where one could purchase sundries, magazines, newspapers, stationary and prescriptions. It had a fountain lunch on the second floor. The first store at that location goes back to 1880, with owner R.P. Reynolds selling provisions and groceries. The first Book Nook appeared around 1915, advertising its fountain and ice-cream specialties like the "snow ball sundae" and serving "Cool refreshing drinks—the purity kind." By the 1940s, it was known as the Balcony Bar with a remodeled look.

The assortment of ice cream from the early days of the fountain lunch included quite an impressive list of names beyond the usual vanilla and chocolate: maple parfait, strawberry mousse, Nesselrode pudding and tutti-fruitti.

Through the years, the lunch counter was managed by people the downtown patrons depended on for consistent and affordable lunches. In 1964, Clemie Schwarz took over the counter. She had a following for her clam chowder and her house-baked pies and cakes. In March 1968, Clemie left the Book Nook and moved across the street to 31 East Main, where she opened her own diner, Clemies.

Mildred "Millie" Roth, in her starched uniform and not a hair out of place, was serving up the best tuna melt in town. In 1981, the fountain lunch

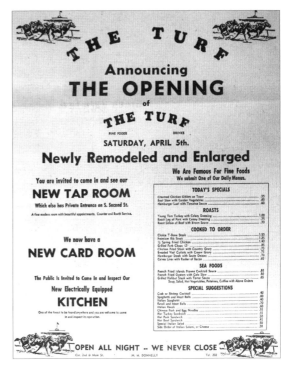

Right: The Turf menu, April 1947; *Below*: An earlier advertisement for the Turf, November 1946. *Courtesy of Joe Drazan, the Bygone Walla Walla Project.*

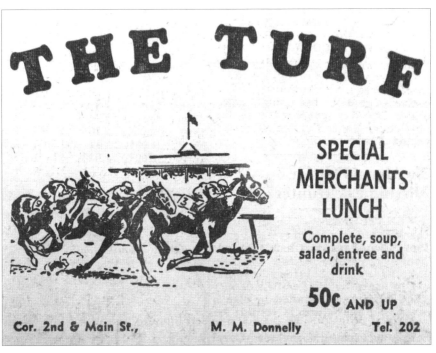

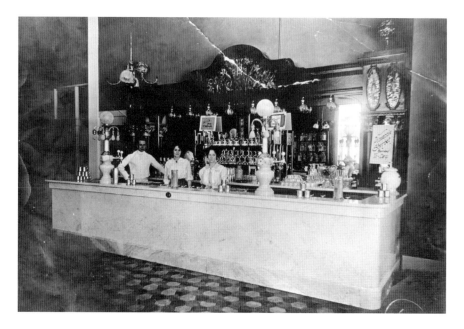

The first Book Nook Fountain, corner of First and Main Streets, 1915. *Courtesy of Joe Drazan, the Bygone Walla Walla Project.*

was known as Jack's Fountain Lunch, with owners John "Jack" and Sharon Shaw. Jack Shaw was a boxer, golfer and restaurateur. He was known for a welcoming voice, announcing for pickup, "cheeseburger deluxe." Jack operated the fountain lunch until the Book Nook's closure in 1993.

The Turf was a popular spot in the back of the Jones building at 10 North Second Avenue, and it had become a new project for Jack before he took over the Book Nook's fountain lunch. The location was a cigar factory in the early part of the century, then the Turf Tavern, then known as Dewey's and back to being the Turf by 1950.

The Turf may have been a tavern, but it was known for some of the best sandwiches, with sides of house-made macaroni and potato salads. It also featured a rotisserie; passersby could catch a view of roasting poultry spinning under the hot lights. It was also the place where pedestrians could catch a view of an attorney, accountant or banker sitting at the counter having a drink for lunch.

After Shaw moved to the Book Nook, another well-known businessman known for taverns and food (the Faucet and the Mill Creek Brew Pub), Gary Johnson, purchased the Turf. The former hot spot lived a good life until it closed in the mid-1990s.

Southgate Drug Fountain Lunch on Second Avenue, known as the Southgate area, arrived in the spring of 1960. It would be the third store from the same local Low Cost Drug Centers, LLC, following downtown's Book Nook and Eastgate Drug Store. The Book Nook had a popular second-floor fountain lunch. Eastgate Drug had proposed one, but it never appeared.

At the time of Southgate's grand opening, its specialties were burgers, chops and "Char-Kel" broiled steaks. Southgate Drug not only sold pharmacy/counter drugs, magazines, cosmetics and candy but was also heavy on fishing and camping gear inventory and sold fishing and hunting licenses. Perhaps the hearty lunch of steaks and chops played into the more masculine camping atmosphere it advertised.

By the early 1960s, the Southgate Drug Fountain Lunch seemed to go with a more traditional lunch menu, with sandwiches, fries and ice-cream sundaes and banana splits. During the school year, it was a popular place to grab an after-school snack.

In July 1993, the Southgate Drug Fountain Lunch closed. The space was eventually absorbed as a result of the next-door grocery store's expansion. The Book Nook, which had been open for nearly a century, closed the same day.

It was grand—and with free coffee! September 23, 1947, was the grand opening of Horton's Fountain Lunch at 104 South First Avenue. It was owned by brothers Bill and Clarence "C.G." Horton. On the day of the grand opening, they offered "free Silex made fresh coffee" with an aim for "real service." Horton's menu offered breakfast food, sandwiches and salads for lunch, steaks and fountain specials. Through the week, it offered "Daily Dollar" meals: roast beef, baked ham, roast pork, baked halibut and barbecue ribs. On Thursdays in November and just before Thanksgiving, it advertised a turkey dinner with all the fixin's for only one dollar. The Horton brothers' hung in there for a decade before shuttering in 1958. A new fountain lunch took over the space.

Wayne and Bertha "Bobbie" Dickey of Dickey's Lunch opened their version of a fountain lunch menu at 104 South First Avenue. This husband-and-wife team typically served food during the breakfast and lunch hours, from 6:00 a.m. to 4:00 p.m. Once in a while they stayed open late on Thursdays with their "Dollar and Dime" special dinners. For a complete turkey dinner with all the trimmings, a customer could reach in his pocket

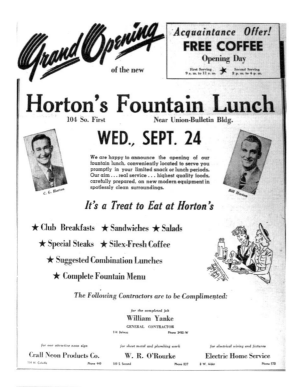

Left: Horton's Fountain Lunch opens, September 1947. *Courtesy of Joe Drazan, the Bygone Walla Walla Project.*

Below: Taking a cola break at Horton's Fountain Lunch, July 1957. *Courtesy of Joe Drazan, the Bygone Walla Walla Project.*

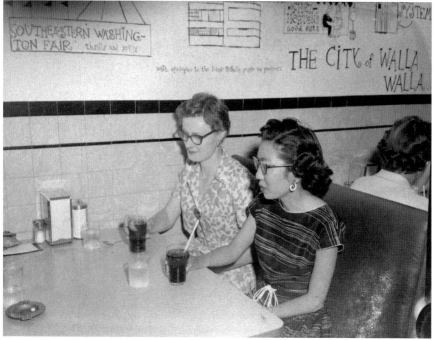

Clarence Horton at Horton's Fountain Lunch, 1950. *Courtesy of Joe Drazan, the Bygone Walla Walla Project.*

and pull out eleven dimes to pay for the meal—$1.10. Other daily dollar dining would be baked salmon loaf, breaded veal, chopped sirloin steak, spaghetti and meatballs and chicken-fried steak. They retired and closed their diner in 1972.

In 1944, friends "Met at the Met"—the Metropolitan at 25 East Main Street. People met there for breakfast, lunch and for dinner steaks. The name of the restaurant had previously been Cain's Café, with George Cain as proprietor. It was a great location for a café, as it was in the heart of downtown. But not all of the dining action happened on Main Street.

In the 1940s, it seemed as if the cafés were serving up a lot of steak for lunch. Roy H. and Charles Cecil were serving up steak—every cut of steak—and all of the filet mignon and hamburger steak you wanted all day

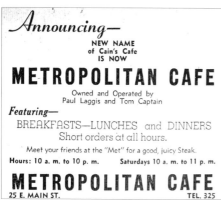

Above: Dickey's Lunch on 104 South First Avenue, September 1959. *Courtesy of Joe Drazan, the Bygone Walla Walla Project.*

Left: Cain's Café renamed Metropolitan Café, July 1944. *Courtesy of Joe Drazan, the Bygone Walla Walla Project.*

and all night at Cecil's Café at 18 East Alder. The location had previously been Miller's Café and, before that, Jack's Place. Jack preferred to serve a lot of seafood. Coffee was always available; the Cecil brothers served Hills Brothers brand, which they "collected" during the coffee rationing days, hoarding it by the case.

The brothers were military veterans but made a decision to go back into government service, and they sold every bit of their business.

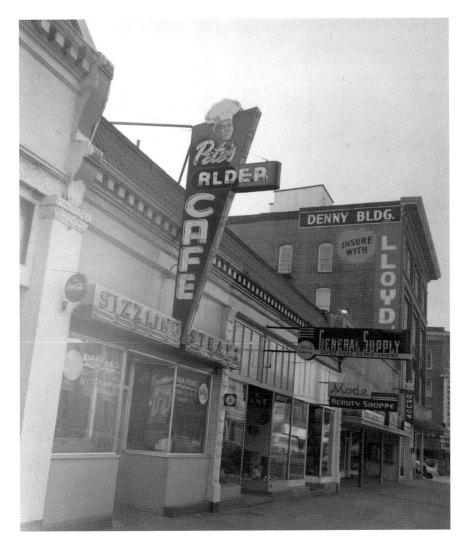

Pete's Alder Café. "Sizzling Steaks" in neon, 1953. *Courtesy of Joe Drazan, the Bygone Walla Walla Project.*

The Alder Café at the same address, 18 East Alder, resumed the business that the Cecil brothers had left with new owner Henry Lilwall. He advertised affordable meals "cheaper than eating at home."

In 1950, L.H. "Pete" Peterson became the new owner of the Alder Café. At the same time, across the street at 17 East Alder, Shelton's Café was a convenient place for the patrons next door at the Grand Hotel. Maybe it was a little healthy competition?

In April 1957, Pete Peterson's diner at 18 East Alder was remodeled, and Pete changed his game plan. It was now Pete's Charcoal Broiler Café and Ranch Room. The remodel included a mahogany interior and a charcoal broiler and rotisserie to put a tasty sear on steaks, prime rib and seafood. A "Sportsman" breakfast and fountain lunch were served during the nine-to-five banker's hours.

It was a grand opening for the "Happy People Feeders," as the new owners referred to themselves, when they opened their doors to the new Café Carrousel on February 23, 1967. It was located in the Schwarz building at First and Main (31 East Main). The new eating establishment, owned by locals Robert and LaNell Pudwill, advertised itself as a cafeteria, buffet, fountain and snack bar. Mrs. Pudwill's sister Lucille Noel, a professional baker, and her husband, Wesley, came from California and joined the local couple in the café partnership. Café Carrousel opened at "baker's hours" as early as 5:00 a.m. and featured baked goods fresh from their in-house ovens. The partners were creative in their marketing; in November 1967, Chef De Marco of Honolulu, Hawaii, became the "consultant" to the management with food "served in nine different dialects," according to an advertisement.

The Carrousel went around and around for a few good months until March 1968, when local Clemie Schwarz, famous for her house-made soups and pies, took over this perfect downtown location. Of course, the dining space was renamed Clemies.

WALLA WALLA HADN'T SEEN A business model like this before, especially one typically seen in old neighborhoods on the East Coast. Merchants Ltd. became Walla Walla's original deli. The front entrance's glass door stated, "Established in 1976."

Chuck and Norma Austin, along with their adult sons Bob and Mike, opened the door at 21 East Main. The Austins restored the 1800s building—or, rather, didn't restore the old building, allowing the original worn brick walls, antiquated posts and high ceilings to provide a natural ambiance. The wood floors told decades of stories about Walla Walla's past, and the seating on the balcony gave way to a bird's-eye view of downtown.

The Austins' original intent was to offer a deli with a selection of gourmet groceries, but their customers dictated beyond the original plan, so Merchants Ltd. became one of the best places in the heart of downtown Walla Walla to order a fresh deli sandwich, an assortment of

house-made soup and salads, a piece of buttery French-style pastry or even a cookie—or two—from the in-house bakery. It was the place to order pies and the French Buche de Noel (Yule Log cake) for the holiday season. The deli selection soon grew to offering several choices of imported cheeses and an assortment of charcuterie, imported groceries and kitchen gadgets, as well as a selection of local wines. As the number of wineries grew in the Walla Walla Valley, so did the selection of wine on Merchants Ltd.'s shelves.

In their decades of food and drink service, the Austins would become known for having contributed many new "firsts" to downtown Walla Walla: espresso, sidewalk seating, a smoke-free establishment and live music. Merchants Ltd. was the first in Walla Walla to sell frozen phyllo dough for this author's yearly baking of baklava, saving a trip to the deli markets in downtown Portland or Seattle.

Spaghetti Wednesday was a popular midweek dining experience. A variety of items were offered to place over noodles besides marinara sauce and meatballs, including browned butter poured over spaghetti noodles and topped with salty Greek myzithra cheese.

Merchants Ltd.'s character and atmosphere usually lent itself for a little quiet time to study, to host a work meeting or to relax and visit with friends. But never at lunch. It truly had the atmosphere of an Old World deli in a New York neighborhood—lots of yelling. If, after waiting in line for a long time to order, a customer still hadn't figured out what to get when her turn came, she might find herself being yelled at for being unprepared. The guilty would then be skipped over, putting a few people ahead until the sheepish patron decided what she wanted for lunch. Of course, this also came with some public humiliation and stares of disdain from the line. It was kind of like being grounded to your room. Hey, the lines needed to move fast. There were hungry people waiting and minutes were ticking away on their lunch hour!

Once an order was placed, customers were given a playing card, and when their order was up, voices were heard throughout the building yelling, "Queen of Hearts! Turkey on whole wheat! Jack of Diamonds! Mortadella on white! Where are you? We don't have all day!"

One also got a good yelling if one walked into Merchants Ltd. with a cup of espresso from another business, especially those cups with a green mermaid on it. And rightly so. They deserved a good yelling—and a spanking. The locals shrugged off the yelling as though it was just "parental love," but sometimes it would raise the eyebrow of a tourist.

Merchants Ltd. closed its downtown deli and market in December 2009. Several weeks later, the Olive Marketplace and Café opened. It did well in keeping some of the old Merchants Ltd. memories alive, except in the most bittersweet way—there's no yelling.

7

Tac-o' the Town

You don't need a silver fork to eat good food.
—Paul Prudhomme

Mexican families first moved to the Washington Territory in the 1860s. Some families raised sheep; others operated mule pack trains. In the twentieth century, especially after the beginning of World War II, Mexican migrants from the Southwest and immigrants from Mexico, including women, made up a large part of the agriculture labor force in eastern Washington.

Carmelita Colón, born in Mexico, was one of those women who settled in the Walla Walla Valley with her husband in the 1860s. Together they ran a mule pack train from Walla Walla to Idaho. When their business failed, they stayed in the area to operate a Mexican restaurant in the early 1900s. The Sebastian Colón Tamale Shop was located at 10 1/2 South Third in the Palace Hotel. In April 1915, the restaurant was gutted by fire and considered a total loss. The Colón descendants continued to live in the Walla Walla Valley until the 1950s.

TODAY IN WALLA WALLA, THERE'S a taco truck on almost every street corner, and for that we are truly thankful. We are also blessed with several talented locals who provide freshly made tamales, tortillas and even bags of fresh tortilla chips—all just a short drive or a phone call away. The

local favorite is the Walla Walla Taco, of course. It's a shredded beef taco on two white, soft corn tortillas and topped with grilled Walla Walla Sweet Onions.

Just so the world knows how great the tacos of Walla Walla are, the August 31, 2013 edition of *USA Today* ranked Dora's Deli, a Walla Walla favorite, number eleven in its list of the fifteen tastiest tacos in America.

Sure, ignore the fact that the little diner shares a space with a bait-and-tackle shop—the publication said that Dora's vegetarian taco scored!

However, Walla Walla wasn't always so fortunate to enjoy authentic Mexican cuisine known for its spicy flavors and a few simple but fresh ingredients creating a multitude of dishes to feast upon.

In the early 1950s, the El Sombrero Tortilla Factory and Café (no connection to the current El Sombrero) opened its doors downtown at 13 South Third Street. It has been noted that Ysidro Berrones was one of the first Hispanic persons to start a Mexican restaurant during that century in the Walla Walla Valley.

Berrones came from a small town, Doctor Arroyo, in the state of Nuevo Leon in northeastern Mexico. At the age of seventeen, he immigrated to the United States and eventually settled with his wife and children in Sunnyside, Washington. However, in 1946, there was no work to be found in Sunnyside, so Berrones made his way to Walla Walla. The Berrones family was able to secure housing at the Walla Walla Farm Labor Homes—and jobs.

Ysidro and his three adult children went to work at the Walla Walla Canning Company. Soon, Ysidro became one of the supervisors. When he wasn't working at the canning company, he took on side jobs, especially in the field of agriculture.

When the tortilla factory and café opened on the corner of Alder Street and Third Avenue, Berrones would often give away his fresh tortillas to potential customers, especially locals born in the valley, so that they would at least take a bite and learn about the "exotic" staple from Mexico. The reception was positive. The café was positive, especially with other Latinos who had migrated to work in Walla Walla's rich agriculture industry. The locals had a place to explore new cuisine that was different from their standard meat and potatoes.

The El Sombrero advertised takeout or inside dining, and on its menu were many delicious standards, such as enchiladas, tacos, fresh-made tortillas and even a dozen tamales for $1.60.

Ysidro's wife, Severa, and their seven children often helped run the café and make the tortillas. As the children got older, they wanted to leave home and the tortilla factory to get married and pursue their own careers. Without the Berrones family around, Ysidro decided to close his business. Around 1967, the El Sombrero Tortilla Factory and Café shut its doors.

Ysidro Berrones died on November 26, 1999, at the age of ninety-four. His daughter Emma Yrias would later say about her father that he felt that Walla Walla had been a blessing to him.

WHAT DO HUNGRY TEENS LIKE as much as hamburgers and pizza? Tacos! In 1971, local Bob Jessee created Outrageous Taco and Pizza Factory, located in the tip of the Flatiron Building (facing Palouse Street at the old train tracks) at 9 Boyer Avenue. It was the place for teenagers to fill up on hard- and soft-shell tacos, burritos, taco burgers, hoagie sandwiches and design-your-own pizzas with numerous toppings to choose from. Outrageous Taco also honored local student ID cards for specials, such as a free Pepsi with a taco or pizza purchase. The majority of the schools at the time had closed campuses, but that didn't stop the youngsters from making a fast getaway in their cars and driving to Outrageous Taco for lunch—and, of course, a repeat performance after school.

In the 1980s, the popular taco hangout relocated to 221 East Main Street. There were a few managers and owners in between, and when Outrageous Taco finally closed its doors and "tac-o hike" in 1996, the remaining owners were Joe Bauer and Greg Baden.

Outrageous Taco and Pizza Factory advertisement, 1972. *Courtesy of Joe Drazan, the Bygone Walla Walla Project.*

Scandalous! Take your clothes off and win an Outrageous Taco! The youth of the conservative city of Walla Walla were streaking on busy streets and college campuses—sometimes even streaking for free tacos.

Streaking is the act of running naked through a public place as a prank, dare, protest or publicity stunt. It became part of mid-1970s' pop culture around the world. However, the wild and crazy youth of the 1960s and '70s didn't create this nude sport. The first streaker was acknowledged in London in 1799. Eventually, streakers showed up at football stadiums, tennis courts, golf courses and even the Olympics.

March 7, 1974, turned out to be a very cold evening in Walla Walla. That evening, a "Streak Challenge" was announced by DJ personality "John Hammond" at 8:15 p.m. over the airways of the local AM radio station, KTEL. The first bold joggers to take up the challenge would receive certificates for free Outrageous Tacos. The timing of the challenge was just before the station program would join ABC News preceding the popular local *Hi-Fi Show*.

Hammond announced at 9:00 p.m. that an exuberant but nude youth by the name of Boris Jones and an unidentified female had hit the streets at the intersection of Second Avenue and Tietan Street, the radio station's location at the time. After the cheeky commotion, the original two streakers shook hands with admirers, were interviewed by Hammond and were presented with their winning taco certificates. But the story didn't stop there.

Soon, other young men joined the notorious two; by 9:30 p.m. that evening, about four hundred young people and area residents were gawking and cars jammed the intersections four blocks long in both directions hoping for a "shot of the moon." As former radio personality John Hammond recalled more than forty years later, "It was a fricken' instant parade!"

But the story didn't stop there, either.

The evening event made its way to downtown at Main Street between First Avenue and Colville Street, and this time it became political, with a streaker holding a sign reading "Streaking for Impeachment," a reference to the current administration of President Richard Nixon. And the story didn't even stop here.

At 10:30 p.m., the crowds moved to College Avenue in College Place, a suburb of Walla Walla, where spectators lined up on the Walla Walla College campus (now known as Walla Walla University) eagerly awaiting more streakers—and they weren't disappointed. Voyeurs were treated to at least eight streakers, several of them female, running across the lawn in front of Peterson Memorial Library. Some of those unfortunate streakers were

students of the college, and they were later expelled. After all, this private, Christian liberal-arts university couldn't have its students running around without, at the very least, a fig leaf.

Meanwhile, in the Eastgate part of town, streaking became a true spectator sport drawing the largest crowds ever. On not just one night, but two nights, spectators stood on Isaacs Street at the Green Lantern Tavern and across the street at Pizza Pete watching pants-less posteriors running across the busy route that was part of the "gut," as in "draggin' the gut." The crowd was so raucous that even the local gendarmes didn't intervene. When the streakers at this location tried to go on for the third night, the police finally had control. An unspoken curfew was enacted.

After it all settled down and the clothes went back on, DJ John Hammond was eventually admonished by the station manager for blurting out this challenge—not too much admonishment, though, as the radio's advertisers, Coca-Cola, and two local businesses, the Bon Marche Department Store and the popular high school hangout the Record Center, loved it.

Ah, youth.

AUSENCIO L. "AL" GONZALEZ WAS a visionary. He arrived in Walla Walla in 1937 from Texas along with his brother Lucio Coronado. As a young man, he was a shoe shiner and a fruit picker. With no formal education, Gonzalez went to work in the Walla Walla Valley as a fruit picker, working for the local food processors Birdseye and Green Giant.

Gonzalez came home one evening in 1967 and announced to his wife, Celia, that they had just bought the Tastee-Freez building at 1005 South Ninth Avenue. Tastee-Freez is a soft-serve ice cream franchise that opened in 1950. Today, there are still twenty-three locations in the United States. Eventually, the Gonzalezes opened the ABC Taco Inn and left the Tastee-Freez burgers, fries and soft-serve on the menu, adding his family's cuisine of tacos, tamales and enchiladas. There was inside dining, drive-through service and even picnic tables outside.

The ABC Taco Inn became a tempting hangout with the Garrison Junior High students. The athletic field was almost at the back door, once you crossed the creek.

Celia and Al both worked the restaurant but took on separate shifts so each one could work a second job to support their family as well as their new business. ABC Taco Inn wasn't the only business the Gonzalezes owned. They also owned the ABC Cab Company. Gonzalez offered the senior

citizens of Walla Walla reduced rates, explaining that it was one way for him to pay back the community that had been good to him.

In 1984, the Gonzalezes' daughter Rosita took over the family business and renamed it Rosita's.

"I was the only Hispanic in my class twenty-five years ago when I graduated from DeSales High School [a private Catholic school]. I can remember back then it wasn't the 'in' thing to eat Hispanic food. Now even convenience stores carry burritos and tacos, and most of our customers are non-Hispanics," Rosita recalled for the local paper, the *Walla Walla Union-Bulletin*, on February 28, 1988. "I was six when we came to Walla Walla, and it was like living in two worlds. We ate tacos at home, and American food out."

Rosita "Chita" Gonzalez-Berrones died on August 6, 2015. She was preceded in death by her father, Ausencio, in July 1985. After her death, the restaurant closed for a while. However, since this writing, other family members have reopened the business.

MIKE AND THEO BYERGO OPENED their doors on the corner of Isaacs Avenue and Roosevelt Street with classic Mexican American favorites on May 31, 1980. Taco Amigos offered a casual atmosphere. Patrons placed orders at the counter for tacos, burritos, enchiladas, taco burgers and taco salads.

The popular Taco Tuesdays, with all-you-can-eat tacos, became a family favorite. It was the perfect place to feed hungry Little League players after a game.

Taco Amigos closed a few years later. It must have been all of those hungry ballplayers that literally ate the owners out of house and home—more like restaurant and kitchen.

When asked, "Where is your favorite place to eat Mexican food?" At home!
—Rosita "Chita" Gonzalez-Berrones (Walla Walla Union-Bulletin)

8

Do You Want Fries with That?

Anybody who doesn't think that the best hamburger place in the world
is in his hometown is a sissy.
—Calvin Trillin

It's no wonder Walla Walla was destined to be home to a variety of diners, taverns and drive-ins that serve a good burger. The term *hamburger* first appeared in print on Saturday, January 5, 1889, when readers of the former newspaper *Walla Walla Union* in Walla Walla, Washington, learned how patrons at a local restaurant were asked if they would have one of the following: "porkchopbeefsteakhamandegghamburgersteakorliverandbacon."

Years later, the *Chicago Tribune*, the *New York Times* and even the *World Almanac* reported this bit of history about Walla Walla's hamburger connection. And Walla Walla has been eating hamburgers ever since—especially when drive-ins became popular.

There are drive-ins and there are drive-throughs, and the two titles are exactly as they sound. At a drive-in, the customer parks their vehicle and is often asked to turn on or blink their headlights for service. Servers, often known as "carhops," walk or sometimes roller-skate out to take orders and serve food on a tray that is hung from the half-open car window. The customer may eat in their car, with the carhop returning to remove the tray and trash, or they may ask for their order to be packaged to-go. The first drive-in restaurant opened in Dallas, Texas, in 1921. Throughout the United States, the drive-in became an iconic symbol in the 1950s and 1960s. At a

drive-through (often abbreviated as "drive-thru"), drivers line up in their vehicles to place an order at a microphone unit and then drive to a window, where they pay and receive their food order to-go. Drive-throughs peaked in the 1970s and '80s, especially with the growth of chain restaurants.

IN 1929, THE PLACE TO meet was the Cabin—and you didn't have to go to the foothills, as this Cabin was just a few blocks from downtown, tucked next door to the former White Temple Baptist Church (now Whitman College's Reid Center) at 214 Boyer Street. In fact, it was advertised as "90 seconds from the City Center." Yes, it really was a little log cabin, and it even offered car service.

The Cabin was opened by LaSalle LeRoux, who later formed a partnership with Francis "Frank" LeRoux and Allen Newman. By day, Frank and Allen were juniors at Whitman College; by night, they were young restaurant entrepreneurs. The Cabin was the convenient hot spot for students from Walla Walla "Wa-Hi" High School and especially Whitman College to share milkshakes and ten-cent burgers and even buy a few school supplies. It was also the place to take a date or find a date after the game, dance or movie. The Cabin offered breakfast, lunch, dinner and midnight snacks in a rustic log-cabin setting with animal heads and school banners on the walls and one of the largest fireplaces in town.

Outside, behind the little Cabin, there was still a lot of undeveloped space, so the Cabin's property was able to hold and serve seventy-five cars with plenty of shade from the old trees in the summer. At night, the space was beautifully lit. In the winter, the lighted area served as an ice-skating rink.

In 1944, the name was changed to Roger's Cabin Restaurant, with Roger Day as the proprietor. The menu changed, offering more dinner choices for inside dining, especially saucy surf-and-turf choices: creamed lobster, Carolina crab

The Cabin, a "new sort of café," opens in September 1929. *Courtesy of Joe Drazan, the Bygone Walla Walla Project.*

cutlets, steamed flounder with egg sauce, scalloped salmon with spaghetti au gratin and sirloin steak with "old English sauce." Generously included with the entrée were a crab or shrimp cocktail; vegetable soup; tossed green salad with French dressing; and a relish tray with kosher pickles, celery hearts and olives. It was a menu with prices that most high school and college kids' palates and pocketbooks were not interested in.

The Cabin restaurant went up for sale in December 1945. Roger, over and out.

The Eastgate area of Walla Walla became a new prime location for merchants with its mid-twentieth-century modern architecture, clean and sleek roof lines, bright fluorescent indoor lighting and bright and blinking neon lights outside. From the local bank to the bowling alley, everything had a different look compared to the grand old buildings of downtown. Through the decades, Walla Walla would see many drive-ins, especially chain drive-ins, get their start in Eastgate.

El Rancho Drive-In at 1919 East Isaacs opened in April 1948 with A.L. "Jim" Jefferis as the manager. The drive-in offered not only curb service but also inside dining for those who weren't quite prepared for the new experience of eating in their car. Echoing the restaurant's name, the El Rancho featured a western flare on its menu with the El Ranchoburger, Piggy-Q sandwich and Chicken in the Rough. The El Rancho's logo was Trigger Pete, a cowboy riding a bucking bronco. The staff prided themselves on "snappy service."

In one of its later newspaper advertisements, the El Rancho had an odd and rather uncomfortable way of suggesting that it was baby friendly—so long as you and your baby partook in the convenient curb service and stayed in your car. The ad featured a drawing of a woman holding a baseball bat in the air, ready to take a swing at a crawling baby in diapers crying "I want my mama!" The cartoon text read, "No more baby sitters. Save the cost!"

Over the years, El Rancho seemed to go through a few owners. Mr. and Mrs. Carl Gregory Jr. owned the business from 1952 until December 1959.

Floyd and Marie Henline, who owned the popular downtown diner the Pollyanna, purchased the drive-in and announced their son Bryce Henline, a recent Walla Walla High School graduate, as the new manager. The drive-in would be renamed Chick's, which was Bryce's nickname. It was remodeled and redecorated during the winter season before it reopened for the warmer weather. It remained Chick's until 1965.

Chick's Drive-In in the snow, located at 1919 East Isaacs, January 1963. *Courtesy of Joe Drazan, the Bygone Walla Walla Project.*

It went through another name change and management change. Honey Huss would be the new manager for the newly named Bernards. The one thing that was familiar to the drive-in, the inside dining room, was renamed the El Rancho Room. Bernards featured a weekly "Bernie's Special," such as shrimp burgers accompanied with a free root beer. The former El Rancho and all of its names would soon become a ghost. It would become "lost" in 1967, and the structure was torn down to make way for a new boat merchant.

UP THE STREET A BLOCK from the El Rancho, a new drive-in was happening. Reed & Bell, also known as Reedies, opened at 2003 East Isaacs in the early 1960s. It was essentially the "American Graffiti" of its time, with carhops and "souped-up and chopped" cars. Inside those hot rods, young women were perched on the middle hump between the bucket seats and straddling the "four on the floor," sitting thigh-to-thigh next to their boyfriends. Nope, seat belts weren't mandatory at the time.

Reed & Bell was one of the stops in the summer while "draggin' the gut." Another stop was at the original A&W building, which has since been torn down. Draggin' the gut was a long and slow route up and down Isaacs Street at Eastgate and back around to downtown's Main Street. It was an opportunity to show off your car and how cool you were—and to see how cool everyone else was, too.

Carhops at Reed & Bell (Reedies) Drive-in, 2003 East Isaacs. *Courtesy of Joe Drazan, the Bygone Walla Walla Project.*

Reedies featured its own proprietary root beer and the R&B Super-Duper Burger. In the mid-1960s, management added a new tagline to the name, Reed & Bell Mugup—"Mug up for root beer."

It was a summer landmark for the teens. The little white-colored stand closed during the winter. It remained a favorite stop until the early 1970s, when it closed for the winter season and never reopened. The covered parking spots where carhops took fries, burgers and milkshake orders remain attached to the building.

THE NAME "WOLFSON" IS SYNONYMOUS with concession stands and amusement rides at the Walla Walla Fair and Frontier Days. It was also one of the earlier hamburger stands. Bill Wolfson was known as the "Hamburger King." His first location was on the corner of Melrose and Wellington at Eastgate in the late 1940s. A hungry camper could get a steamed burger for thirty cents, served in one's car. Wolfson later brought to Walla Walla fish and chips, shrimp and chips, chili burgers, barbecue sandwiches and foot-long hot dogs. Also, sundaes, shakes and banana splits were served, made with ice cream from the local Shady Lawn Creamery (the old creamery building still remains and is now an antique shop).

SHOWING YOU WOLFSON'S NEW DINING ROOM

Bill started out as a Hamburger King—Next he brought Walla Walla Fish 'n Chips—
Now It's Sea Foods, Steaks and Salads...Basket Foods served in your car...Steaks,
Chicken, Sea Foods served in our new Dining Room.

TEL. 3084 FOR TAKE-OUT ORDERS

Wolfson's Drive-In

WELLINGTON & MELROSE ST.
Open 5 P.M. to Midnight—Saturday Night until 1:30 and Closed Mondays

Above: Wolfson's Drive-In expansion on the corner of Melrose and Wellington, July 1948. *Courtesy of Joe Drazan, the Bygone Walla Walla Project.*

Left: An advertisement for the new dining room at Wolfson's Drive-in, February 1950. *Courtesy of Joe Drazan, the Bygone Walla Walla Project.*

The drive-in building started out as a little trailer that Wolfson moved to the corner location. Originally, the mobile unit was intended to be moved from fair to fair. After a year of service at the corner, Wolfson added a few shingles on the trailer, enlarged the structure, added a new kitchen and made the new "building" permanent.

In the 1950s, Wolfson moved to the corner of 429 South Ninth and Chestnut. The vibrant little hamburger joint had a walk-up window for patrons to place orders. Driving by the business, you couldn't help but notice at the five-way corner the large neon sign the shape of a milkshake and several Coca-Cola signs surrounding the building. In 1959, the little building changed ownership. David Nordman changed the name to his new drive-in, Dave's Drive-In.

A LOCAL VISIONARY ONCE CREATED a drive-through with the attitude of today's mini-mart but resembling an old dairy barn. It became handy for parents leaving work to drive though on their way home to pick up a gallon of fresh milk and a pack of cigarettes and, later in the evening, to bring the kids for a scoop of maple nut ice cream in a cone. One stop, and you never had to leave your car. This unconventional local businessman and inventor, Barnard "Barney" Tomlinson, later invented the Squareball Stickyless Popcorn Co., but most of all he would create square hamburgers ordered by the length. Move over, Wendy's.

In the fall of 1968, the Launching Pad opened on the corner of South Ninth Avenue and Emma Street. The combined diner and drive-in restaurant's decor resembled an office for an astronaut in space. The Lunar Terrace, a garden of exotic plants, was separated by the Flying Saucer dining area and its three-dimensional rocket ship decor.

Oh, and the restrooms? Let's just say they provided a countdown to launch with blinking lights. Even the drive-through had the spaceship theme, with patrons placing orders on Concourse 1, then moving ahead to Concourse 2 or Concourse 3 to await or complete the delivery. The outside of the building featured a border of psychedelic-colored twinkling lights, which provided the effect of a spinning roof, like the top of a spaceship.

The food featured the clever square hamburgers ordered by the length, for which Tomlinson invented a square extruder of square prime ground beef. It was suggested that children may prefer a small size, such as a Mercury or Jupiter burger, while a hungry man would order the Atlas. The menu also included fried chicken, salads, fried pies, fountain

service and forty varieties of doughnuts prepared by the in-house baker, Ralph Brown.

Tomlinson and his partners, Mr. and Mrs. Gadwood, had hopes of franchising this futuristic idea. Sadly, the rocket never got off the ground. The Launching Pad was lost in space in the year 1972.

THE TALE OF TWO ROOT beer–centric drive-ins, A&W and Triple XXX, each with a long history dating to the early 1900s, would eventually find its way to Walla Walla.

In June 1919, Roy W. Allen opened his first root beer stand in Lodi, California. In 1923, the "W" provided the finishing touch when Frank Wright joined Allen. Together, they opened their first A&W in Sacramento. This new drive-in would provide curbside service featuring "Tray Boys" and "Tray Girls"—eventually, these proper names would be simplified to "Car Hops." Women soon replaced male carhops during World War II, as most of the young men were in the armed services. Restaurants discovered that an attractive young woman sold more food than young men. In 1924, Allen purchased Frank Wright's stake in the business. By 1925, Allen had begun franchising his stands. As seen today, the A&W became a success. By 1950, Allen had sold the company and retired.

The A&W root beer stand made its first appearance in the Eastgate area in the mid-1950s on a piece of land that wasn't even considered part of Isaacs Street. Everything east of the busy intersection of Isaacs and Wilbur had as its address Route 1, according to 1950s Walla Walla city directories. The first owners of the little A&W were James and Claire Nordstrom. Later, the owners were Reid and Marie Malin until the mid-1960s. It was then that the A&W was acknowledged with a new address, 2139 East Isaacs, instead of the former Route 1.

In the mid-1960s, the A&W fell under the management of A.L. Gabrielson until 1966, when Edgar "Mr. Ed" Volkman purchased the root beer business.

In the A&W expansion years of the 1950s and '60s, the franchisees were signing twenty- or twenty-five-year contracts under the older franchise model. The menu included hamburgers, fries, hot dogs and the Coney Island dog—a hot dog served on a bun and topped with a tomato-based sauce of ground beef and seasonings. Added on top of the sauce-laden hotdog was grated cheddar cheese and finely chopped onions.

In 1963, A&W introduced four choices of hamburgers and its corresponding Burger Family members: Papa Burger, Mama Burger, Teen

The original A&W located on Route 1, 2139 East Isaacs (address is no longer and was absorbed by Eastgate Mall), June 1957. *Courtesy of Marsha Nordstrom Fortune.*

Burger and Baby Burger. Each burger had a wrapper featuring a cartoon image of the corresponding character. The Papa Burger consisted of two one-eighth-pound beef patties, with two slices of American cheese, lettuce, tomato, onion, pickles and A&W's proprietary sauce (similar to Thousand Island dressing) on a sesame-seed bun. The Mama Burger was the same, but with a single one-eighth-pound patty and a plain bun. The Teen Burger had a single quarter-pound patty and included slices of bacon (also served on a sesame-seed bun). The Baby Burger was made with one one-eighth-pound beef patty, ketchup, mustard and pickles, served on a plain bun. With the Teen Burger, it's been claimed that A&W was the first drive-in to introduce bacon on top of a hamburger.

Like its neighbor down the street, Reedies, the little A&W was a hot spot for teenagers in the 1960s and the early '70s. The small building, which had only room enough for the front fountain area and back grill and storage, stood in the middle of an incline surrounded by bare, weedy lots. It became an important part of the "gut," as cars would pull into one of the two entries and circle around to the back of the A&W building, then maybe circling again while checking out the carhops and the parked cars, seeing who was being cool chugging down a root beer or a mug of "swamp water." Then, once the loop was finished, and before management came out, the car would leave through the opposite entry and continue its drive down the "gut," and maybe even come back to do the loop in an hour or so.

In the 1970s, the A&W Corporation moved to a modern-style franchise agreement, which introduced royalty payments and new standards. What this also meant to Walla Walla was that, in 1974, the little structure that had housed the A&W for twenty years would soon be absorbed by a new mall and parking lot. The original little A&W was demolished, leaving many teenagers of the late 1960s and early '70s with bittersweet memories.

Local owner Ed Volkman built a new and larger structure to house the A&W shortly after the original space closed. The new A&W at 2555 East Isaacs would contain all of the newest features. A carhop would no longer come out to your car to take your order. Instead, the customer would place her order into a speaker, and wait staff would bring out the order on a tray attached to the patron's half-opened car window. Also, parking was now under a carport, so the wait staff and the customer would no longer have to brave the elements. The new business also had indoor seating, with speakers at the tables for customers to place orders. Waitstaff would bring the order to the table and collect the owed funds. This newfangled idea of limiting carhops seemed to lack the attraction for teens to make the loop back down "the gut."

As the twenty- or twenty-five-year original A&W franchise agreements expired, many franchisees refused the revised terms. A frustration with many A&W franchise owners at the time, and also for Volkman, was the competition by the head corporation's promotion and selling of canned and bottled A&W Root Beer. Once that promotion began, Volkman's root beer sales slipped drastically—for example, from fifty gallons on a busy Sunday to only three or four gallons.

Around 1979, Volkman left the A&W franchise and renamed his business Mr. Ed's. The restaurant still remains, under different ownership. Today, it serves more than just burgers, and Mr. Ed's is a popular place for breakfast.

Years later, the A&W franchise eventually returned to Walla Walla, merging with KFC in 2001 at 595 West Rose Street.

When we used the A&W as a turnaround when driving up and down Isaacs Street, we would stop to talk with all the girls. I can still hear Mr. Volkman, the owner, telling us to buy something or move on. We ordered "baby root beers." We also made a game out of "collecting" the paper numbers they [carhops] would put on the car windshields after you place your order. I kept them in my glove box for several years. Great memories.
—Gordon Grassi, class of 1972, Walla Walla "Wa-Hi" High School.

The name Triple XXX was first created as a beverage brand, when its root beer was produced for sale in 1895. Eventually, by the 1920s, around one hundred Triple XXX Thirst Stations would dot roadways throughout the United States and Canada. The Thirst Stations became diners with counters and drive-in service. The Triple XXX Drive-In's tagline was, "We were here before your mother was born"

The very first Triple XXX to become a drive-in was in Washington State, in Renton, an eastside suburb of Seattle. Owner Archie Rutherford continued to open a chain of Triple XXX drive-ins throughout the Pacific Northwest in the late 1930s and early 1940s.

In Walla Walla, the Triple XXX Drive-In was opened in 1933 by owner G.W. Mulcihy. The double-barrel roofline structure built in 1933 was originally located on the east side of Ninth Street Highway, what is now known as 1415 Plaza Way. A year after the building was finished, due to a land dispute, the odd-shaped building was moved to the west side of the Ninth Street Highway (now known as 1410 Plaza Way). No matter where the building was placed, it could be seen for blocks away due to the unique roofline.

Like the A&W, the Triple XXX menu offered not only frosty mugs of root beer, but also burgers, fries and milkshakes. The former Walla Walla Triple XXX's menu also featured fish and chips, fried chicken, barbecue beef sandwiches and, in later years, breakfast.

Ed Volkman, who owned the A&W and later Mr. Ed's, purchased the business in August 1969 along with Bea Boatman, who had been part of

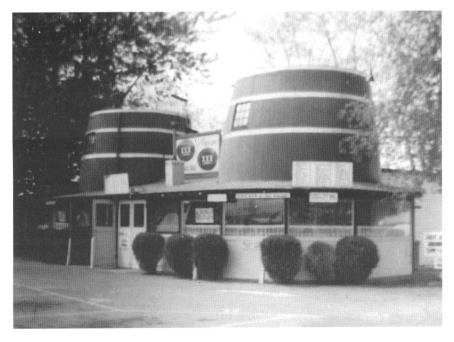

The second and final location (across the street from the original location) of the Triple XXX Drive-In. It was razed in 1972. *Courtesy of Joe Drazan, the Bygone Walla Walla Project.*

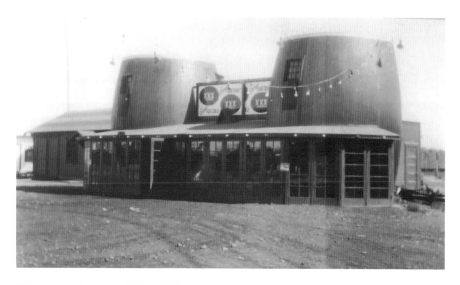

The original site of the Triple XXX Drive-In, formerly on the east side of Ninth Avenue. That portion is now known as Plaza Way. *Courtesy of Joe Drazan, the Bygone Walla Walla Project.*

the Triple XXX operations for many years. It had been announced just before their traditional seasonal winter closure that there were changes to the menu, including a "burger family" added to the new menu. The long story short is that the old Triple XXX root beer suds became washed up; the endearing but unusual structure was razed in 1972.

At present, there are two Triple XXX drive-ins still in operation, in Issaquah, Washington, and in West Lafayette, Indiana.

THE ARCTIC CIRCLE WAS ANOTHER popular franchise in the Walla Walla area, and this one in particular made an impact on young families and especially teens because of its value pricing, including the nineteen-cent hamburger, sixty-nine-cent fish and chips, the Circle A Ranch fried chicken dinner for a whopping eighty-nine cents and the "Bag of Burgers" deal.

On September 22, 1961, Richard and Gwen Talbot, originally from Henderson, Nevada, held a grand opening for their first Walla Walla Arctic Circle, located on the corner of Isaacs and Roosevelt Streets at Eastgate. At the time of the opening, there were around one hundred franchises. The Talbots celebrated a second grand opening in 1967 for the new and second Arctic Circle, located on the corner of Ninth and Alder Streets. Around

1974, due to divorce and death in the partnership, the Walla Walla Arctic Circle franchise leases ran out.

In the fall of 1979, Arctic Circle popped up once again in a new location and new building at 1815 East Isaacs. This time, the land and structure were owned by the Salt Lake City–based corporation, Arctic Circle. Unfortunately, it wasn't as well received as the former local Arctic Circles. It proved to be very short-lived. After a quick closing, the Arby's chain immediately took its place.

Today, there are fewer than seventy Arctic Circles located in Utah, Idaho, Nevada, Oregon, Washington and Wyoming.

Did you ever wonder what made the Arctic Circle "secret sauces" so... secret? Well, on good authority, the "secrets" were revealed by a relative who had worked for years making the Arctic Circle Fry Sauce and the Arctic Circle special burger sauce that was used to top the nineteen-cent burger.

The popular fry sauce is really no secret. It's a combination of mayonnaise and ketchup to taste. Some copycat recipes claim that pickle juice or buttermilk is added. Not according to the source that made these

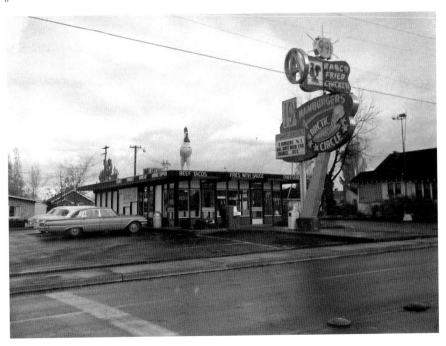

The Arctic Circle at 1707 Isaacs, 1964. *Courtesy of Joe Drazan, the Bygone Walla Walla Project.*

sauces for years. In the 1960s, this combination of condiments was new, but today, just about every burger joint has its own variation, or the same combination with a proprietary name. Let's just conclude that the Arctic Circle was the leader when it came to the secret fry sauce.

Now, about that Arctic Circle burger sauce. It was a combination of mayonnaise, buttermilk to lightly thin the sauce and a dash of white pepper.

RED STEER DRIVE-INNS, LLC WAS founded in 1965 by the Hawkins brothers of Boise, Idaho. Eventually, the brothers found their way to Walla Walla, and on July 9, 1970, the Red Steer Drive-Inns had their grand opening in the Eastgate area at 202 North Wilbur Street. It became a popular drive-in for the area; there would soon be a second Red Steer Drive-Inns at 320 South Ninth Avenue around 1973.

The Hawkins didn't want to sell just any regular burger. They added extra on the burger to produce their trademarked Ham'Oneer, Bac'Oneer, Taco Burger and Big Red Burger, which included—but not to be outdone by—"two all beef patties, special sauce, lettuce, cheese, pickles, onions on a sesame-seed bun.™"

Last but not least, the Red Steer Drive-Inns featured dinners in a box. Their boxed dinners included a choice of shrimp, fish or the popular Crinkle Steak Dinner, with a side of crispy Tater Sticks, a slice of buttered toast and dipping sauces. The Crinkle Steak Dinner was the most popular dinner at the Red Steer Drive-Inns and had a history all its own.

Currently branded as the Idaho Finger Steaks, these spicy battered strips of steak were first produced by a butcher for the U.S. Forest Service in McCall, Idaho. While wondering what to do with leftover tenderloin scraps, butcher Milo Bybee came up with the idea to batter and fry the strips. These tasty strips made their debut with Chef Milo at the Torch Lounge in 1957 in Boise. The finger steaks were later produced by a frozen-food company founded in 1972 to supply the signature tasty strips to the Red Steer Drive-Inns.

The Red Steer Drive-Inn at the Wilbur Street location was closed by 1985. Shortly after that, the building became a video store. The location on Ninth held in there a little longer, but by 1989, the last Red Steer had been put out to pasture. The Red Steer Drive-Inns are no longer in existence.

Today, many former Red Steer Drive-Inn customers still pine for just one more bite of a Ham'Oneer or a Bac'Oneer.

Afterword

*If anything is good for pounding humility into you permanently,
it's the restaurant business.*
—Anthony Bourdain, chef, author and television personality

On November 27, 1984, the *Walla Walla Union-Bulletin* posted on the front page an article by Sarah Jenkins, "Statistics Prove Walla Walla Is a Tough Place for Restaurants." It listed five restaurants that became "lost" in the months preceding the article while giving heed to the four new restaurants popping up on the slumping Walla Walla restaurant scene.

> *It's not just Walla Walla—nationally, restaurants have the 10th worst survival record. Some 17 out of every 10,000 established restaurants, in fact, close their doors every month, according to a Dunn & Bradstreet report. And the estimates for new restaurant failures—those that don't survive their first year—are even higher. Or it may be just Walla Walla—per capita spending in restaurants in Walla Walla County is less than half that for Washington state. While Walla Wallans spent $550.18 each in eating and drinking establishments last year, the "average" Washingtonian spent $1,223.27. Together, those statistics have made for a tough few years for Walla Walla restaurateurs.*

The timing of the article is rather a compelling one, as during the same year, while Walla Walla was on the decline, the Walla Walla Main Street

Foundation (the Downtown Foundation) had just been formed by business and downtown building owners. Also, the Alcohol and Tobacco Tax and Trade Bureau (TTB) of the U.S. Department of the Treasury named Walla Walla an American Viticultural Area (AVA). This was a good start for the little town so nice they named it twice, and what the readers of the depressing article may have not known at the time was that Walla Walla would soon be on the road to the "way it used to be."

In 2015, a study was prepared for the Washington State Wine Commission by Community Attributes, Inc., a Seattle research and analysis firm specializing in regional economics. The report indicated that in 2014, 808,000 tourists visited Washington wineries 2.1 million times, and while visiting the wineries, they spent $193.1 million and supported about 1,800 jobs. Woodinville, a King County suburb, part of the Seattle metropolitan area, was listed as number one in wine tourism. And where did Walla Walla Valley stand?

In the report, the Walla Walla Valley was listed as second in the state in wine tourism destinations. However, its wine economic impact was higher than that of Woodinville, due to Walla Walla being nestled in the southeast corner of the state, drawing more tourists who needed lodging for at least one night and at most two or three nights, therefore spending more time in restaurants. The Woodinville tourists were from the Seattle area and typically traveled for just a day outing.

In the same edition of the *Union-Bulletin* of November 27, 1984, the previous article accompanied a second article, "You Can Have the Best Intentions," which included interviews of restaurant owners and their advice and viewpoints about the business. Local businessman Alan Raguso, who assisted his father, Sam, and also managed the restaurant during the successful era of the Red Apple, was quoted:

> *"The restaurant business is not necessarily something you learn out of a book," he says, noting his own college background in economics and law. "You learn it more from working hard, long hours. Making that education a success, however, requires a variety of factors: • You need a product you can market, • A good location, • The ability to compete with other restaurants, • An understanding of the market, • An aptitude for dealing with people, • And consistency in all of those."*

In my research cultivating names and dates, one of the things I noticed was a continued thread through the decades when owners sold their successful

turnkey restaurants: as soon as the new owner took over management, they enthusiastically made immediate and somewhat drastic changes—and many made significant changes to an already successful restaurant. It was then that, within three years or less, the business would close.

Perhaps that is an example of how the dining public are creatures of habit, which would often explain the success of chain restaurants: the customer can rely on consistency. There are very little surprises for the diner, who knows that the meal they enjoyed in one town will probably taste the same in the next.

Consistency is the key, and this proved to be true when an enthusiastic new owner of a longstanding local restaurant changed the bleu cheese dressing that had been adorning the popular iceberg lettuce salad for years to a cheaper brand—and admitted the change when he was asked why the salad that customers had ordered for more than twenty years tasted different. The establishment closed shortly after the new owners purchased the restaurant. This is just one of millions of stories all over the country, wherever there are dining customers and wherever there are restaurants.

THROUGHOUT THIS BOOK ARE SUCCESS stories of longstanding dining institutions, and of entrepreneurs who never gave up. Owning a successful restaurant is about dedication, and it was reinforced by Walla Walla restaurant leaders, among those a few who are no longer with us: Eugenio DeLuca, Bill Eng, Frank Fazzari, Ausencio "Al" Gonzalez, Harold Jackson, Jerry Manuel, A.J. "Abe" Mathison, Sam Raguso…

> *Walla Walla always was a good restaurant town.…There aren't so many restaurants downtown, as there were in the 30s and 40s.…To the young people just starting out, I'd say, "Do something for your community." That's the important thing to remember, be an active member of whatever you are in. Get involved.*
> —*A.J. "Abe" Mathison, February 8, 1981, Walla Walla Union-Bulletin*

Of those who were not listed in the chapters but not forgotten are the following: Abby's Pizza, the Addition Restaurant and Tea Room, Andy's Coffee Shop, Air Terminal Coffee Shop, Antler's Café, Barnes Café, Becks Fountain Lunch, Bershaw's, Bob's Sub Shop, the Circle Shop, Country Kitchen, De-Ve Grill, Dew Drop Inn, DJ's, the Dug-Out, Eddie Mays, Everett's Café, Foghorns, Fourth Avenue Café, Frosty Island, Garland's

Everett's Café at 25 East Main, February 1947. *Courtesy of Joe Drazan, the Bygone Walla Walla Project.*

Coffee Shop, George's Café, Golden Gate Café, Greenway Inn, Grotto Café, Hindquarter, Incredible Edibles, Jensen's Tea Room, Jumbo Johns, Keglers Lunch, Kenworthy's Fountain Lunch, Kirk's Coffee Shop, Klinkers, Knights Café, Kordons, Little Gem Café, Lytle's Café, Marty's Drive In, Molly's Cottage, the New York Coney Island, the Orient Café, Pies and Stuff, Prime Cut, Quick Stop Lunch Shop, the Royal, Shire Inn, Smitty's/Perkins, Tighe's Café, Tommy's at the Airport, the Trolley Inn, Yogie's...

Restaurants have personalities, just like people. They run the gamut from the steady community anchor, to the ditzy passing fad, to the dysfunctional flop. Those that succeed do so because they change little when they do something well, and continuity and consistency are measured in years rather than months. They are the steady places to which we like to return to be reminded that when all else seems out of whack, some things don't change.
—Christopher Cook, "The Hour," Detroit magazine food critic

Recipes

There are so many recipes that many of us wish we could have captured through the years from our favorite Walla Walla restaurants of the past. Then again, would those recipes taste as good coming from our kitchens as they did at the restaurant? Our memories of these restaurants had to do with more than the flavor of the food. The food also commemorated special moments in our lives and what was happening in our city. In fact, often what was happening in our world was influenced by the economy, immigration and trends.

Here are a handful of recipes to enjoy and possibly to re-create some old memories—or even create some new ones.

———— ⇒✖⇐ ————

Left Bank Shrimp Helene

Raw prawns or large shrimp, about 6 count
Tomato, thinly sliced
4 eggs
1 cup of cream
1 cup of crumbled Feta cheese
Lemon
Ground white pepper

Sauté prawns in clarified butter until just barely pink. Place prawns in baking dish. Blend well eggs, cream, and feta cheese. Pour egg mixture just to the top of prawns. Arrange about two slices of tomato on top. Bake at 400 degrees for about 10 minutes. Remove from oven and sprinkle with lemon juice and ground white pepper.

Swamp Water

This popular drink in the 1960s was first concocted at the A&W drive-ins. This murky-looking drink wasn't typically listed on the menu, so it had to be requested. It was often desired by athletes and the "cool" guys who didn't want to be drinking the same drink as the girls. It was the bravest of men who would ask for a "lillie pad floating on top of the swamp"—the garnish of a floating dill pickle slice.

2 parts A&W Root Beer
2 parts orange soda

Mix the two well-chilled sodas in a pitcher and pour the dull and dirty-looking liquid into your favorite mug. Serve chilled. Top with a "lillie pad" or two. Add a couple dollops of vanilla ice cream for a cloudy-looking Swamp Water float.

It's been said that Swamp Water was created due to the popularity of "Swamp Pop" from the 1950s and 1960s. The music was a blend of honky-tonk and Cajun music and included songs like "See You Later, Alligator" by Bill Haley & His Comets, "Sea of Love" by the Honeydrippers (it was a number one hit by Phil Phillips as well) and several songs recorded by Jerry Lee Lewis, Elvis Presley and Creedence Clearwater Revival.

The Left Bank Creamy Cucumber Salad Dressing

This was a popular house salad dressing, made fresh and served drizzled over fresh green salad. Nadean Pulfer, daughter of Bob and Phyllis Pulfer, owners of the Left Bank Restaurant, remembers that the chives used for this favorite salad dressing were picked fresh from "her mum's garden."

½ cup mayonnaise
½ cup sour cream
2 tablespoons fresh chives
1 cucumber peeled and seeded (or seedless English cucumber)
1 teaspoon fresh dill (or dried)
1 teaspoon vinegar
Salt and white pepper to taste
1 tablespoon milk or so if needed to thin mixture

Finely chop chives. Peel and seed cucumber. Finely chop cucumber or lightly pulse in food processor to measure around a ¾ cup. Whisk together mayonnaise, sour cream, vinegar and chives. Add chopped cucumber. Stir in milk as needed to thin mixture. Add dill, salt and pepper to taste. Cover and chill for several hours or overnight before serving.

The dressing not only is delicious over salad greens but wonderful as a dip for fresh vegetables or even shrimp.

I still have the chives plants and think of her [my mother] *every time I go out to the garden and cut some.*
—Nadean Pulfer

Snowflake Potatoes

In reviewing many of the Walla Walla hotel menus from the 1930s and 1940s, one of the items that remained consistent was the potatoes served at dinner, especially a potato dish served at banquets listed as "snowflake" potatoes. The potato dish was also on the menu of Seattle restaurant the Edgewater Inn during Thanksgiving 1961.

Was "snowflake" the name of a potato entrée or of a garden variety? Research indicates that snowflake potatoes were common on restaurant menus from 1928 to 1954. It was reported that snowflake potatoes were part of the menu served during Thanksgiving in 1950 for the U.S. armed forces in the Far East and Korea.

More research indicates that a cookbook written in 1887 by Mrs. F.L. Gillette makes mention of "snowflake" potatoes served at the White House.

4 pounds mashed potatoes
1 (8 oz.) package cream cheese, softened
1 cup sour cream
2 teaspoons salt
¼ teaspoon pepper
1 clove garlic, crushed
¼ cup chives, chopped
½ teaspoon paprika
1 teaspoon butter

Mix potatoes, cheese, sour cream, salt, pepper and garlic. Stir in chives; sprinkle with paprika and butter. Bake at 350 degrees for 30-45 minutes. The recipe added, "Nice to serve for that company dinner."

Quiche à la Left Bank

Quiche is considered a French dish; however, the practice of using a blended mixture of eggs and cream in pastry and baked like a savory custard was practiced in English cuisine in the fourteenth century and considered to be a dish of Italian cuisine at least as early as the thirteenth century.

There are many versions: quiche au fromage (quiche with cheese) and quiche aux champignons (quiche with mushrooms) or florentine (spinach) and provençale (tomatoes). Also, quiche Lorraine, named after the Lorraine region in France, is an addition of cheese and lardons (bacon).

In 1818, Walla Walla's Frenchtown was established near the mouth of the Walla Walla River, associated with the Hudson's Bay Company. When French Canadians arrived to build the Northwest Company post, it's rather doubtful that they dined on quiche. Thank you to Nadean Pulfer for sharing the quiche à la Left Bank and shrimp Helene recipes.

6 ounces mushrooms, sliced thick
1 ⅓ pints half & half
1 tablespoon lemon juice
1 tablespoon Madeira wine
2 teaspoons salt
2 ounces shredded Swiss cheese
2 tablespoons chopped green onions
1 tablespoon chopped fresh tarragon, remove leaves from stems
1 dash nutmeg
1 dash coarse ground white pepper
1 unbaked pastry pie shell

Sauté mushrooms in butter, lemon juice, salt and Madeira. Add tarragon to mixture. Sprinkle shredded cheese on the bottom of the quiche pastry pie shell. Strain mushrooms from the liquid and place mushrooms on top of cheese. Sprinkle on top of mushrooms the chopped green onions. Combine half & half and eggs with a whisk. Pour egg mixture into pie shell covering cheese, mushrooms and onions. Sprinkle in the dash of nutmeg and white pepper. Bake in oven at 425 degrees for 15 minutes. Then lower the oven temperature to 350 degrees and bake for 20 minutes or until the quiche is set. Allow to cool at least 10 minutes before serving.

Popular Chinese Restaurant Pineapple Chicken

This recipe has been a family standard coming out of my kitchen and was given directly to me from the authentic source more than thirty-five years ago.

2-4 pounds. boneless chicken breasts cut into generous bite-sized pieces
4 egg whites

Beat egg whites until stiff like a meringue. Dip cuts of chicken in the egg-white batter. Deep fry chicken in deep fat fryer or use a deep pan approximately half full of vegetable or canola oil and heat to between 350 degrees and 375 degrees. Fry chicken in small batches, turning occasionally, until golden brown and cooked through, 6 to 7 minutes per batch. If chicken darkens too quickly, reduce heat. Transfer finished chicken to paper towels to drain. Keep warm.

Sauce:
¼ teaspoon ginger root, grated or use powdered
½ cup sugar
½ cup white vinegar
6 tablespoons pineapple juice (may use juice from canned pineapple chunks)
1 tablespoon cooking sherry
1½ tablespoons corn starch
4 tablespoons water
15–16 ounces canned pineapple chunks, drained (reserving 6 tablespoons of juice as listed above)

Mix corn starch and water together in bowl and set aside. In heavy saucepan add ginger, sugar, vinegar, pineapple juice and sherry. Over medium heat bring to boil while stirring. Lower temperature and slowly stir in the corn starch and water mixture and continue to stir until sauce is smooth. Add drained pineapple chunks to warm. Pour over battered chicken and gently combine, making sure each piece is well coated. Serve with a side of white rice.

Optional: the original recipe suggests adding two drops of red food coloring to the sauce for "authenticity." Also may top finished dish with a sprinkling of sesame seeds and a finely chopped green onion. Sauce could be made ahead of time, later adding pineapple and chicken.

Red Steer Drive-Inns Finger Steaks—Original Milo's Torch & Lounge Cafe Finger Steaks

Upon researching several Idaho newspaper articles and websites, this seems to be the most agreed-upon recipe as being "authentic" and often referred to as "Idaho Finger Steak."

The recipe is best made with the background music of Bachman-Turner Overdrive and the Doobie Brothers. Most important, don't forget the glass of Annie Green Springs Country Cherry wine. It makes for the perfect food and wine pairing.

1 ½ cups milk
1 teaspoon dried thyme
1 teaspoon dried marjoram
1 teaspoon salt
2 tablespoons seasoned salt
¾ tablespoon Worcestershire sauce
2½ cups flour
4 cups oil for deep frying
3 pounds beef tenderloin, cut into 2½ x ¾-inch strips

Mix together the milk, thyme, marjoram, salt, seasoned salt and Worcestershire sauce in a bowl. Stir in the flour gradually until the mixture reaches a thick, batter-like consistency. Refrigerate 1 to 2 hours.

Preheat oil in a large pot or fryer to 375 degrees F (190 degrees C).

Completely coat each piece of beef in the batter and gently place into the hot oil. Lay each strip into the oil individually to keep them from sticking together. Cook in small batches of 4 to 8 pieces until golden brown for about 5 minutes. Allow the oil to return to 375 degrees F (190 degrees C) between batches.

Serve with barbecue or spicy tomato horseradish cocktail sauce for dipping.

Kraut Brot

This recipe has been passed around through the Walla Walla German community for many years. I've had this recipe for more than thirty years. There have been many names for this pastry-filled pocket, including Kraut Brot (cabbage bread) and runza in the Midwest. Sometimes within families, they have been referred to as Kraut Nancies.

1 ½ pounds hamburger
2 cups shredded cabbage
1 cup chopped onion

Saute hamburger until crumbled. Be careful not to dry out by browning. Set aside. In fry pan, steam the onions and cabbage. Mix with meat. Sprinkle with salt, seasoning salt, pepper and marjoram to taste. Set meat/cabbage aside.

Refrigerator Dough:

2 cups hot water
½ cup sugar
½ cup shortening
1 tablespoon salt
2 eggs
2 packages of yeast
½ cup water
8 cups flour

Dissolve two packages of yeast in ½ cup of warm water. To lukewarm mixture add two beaten eggs and two cups of flour. Add yeast mixture and another two cups of flour. Mix well and add the final four cups of flour. Knead dough for about five minutes. Let raise or place in refrigerator and cover. Dough will keep in refrigerator for up to a week.

After dough has risen, roll out on an oblong sheet. Cut into 3 x 3" squares. Place heaping tablespoon of hamburger cabbage mixture in the middle of each square. Bring up the opposite corners of dough and pinch together. Place the bundles on greased cookie sheet with the pinched sides down. Let rise until light. Bake at 350 degrees for 15 minutes until brown.

Left Bank Crepes

Crepes are especially popular throughout France. The common ingredients include flour, eggs, milk, butter and a pinch of salt. There are usually two types of crepes dependent on the topping or the filling—sweet or savory. This recipe is made to serve for dessert. Thank you to Nadean Pulfer for sharing this recipe.

4 tablespoons of butter, melted and cooled
4 eggs, room temperature
1 ½ cups whole milk

Dry ingredients:

1 cup flour
2 tablespoons sugar (omit sugar if using for savory topping or filling)
¼ teaspoon salt

Mix butter, eggs and milk. Mix together dry ingredients and add to wet ingredients a little bit at a time until both mixtures are well incorporated. Cool and let batter rest for 30 minutes or longer.

Pour batter onto medium-sized crepe pan or heavy bottom stainless steel pan. If needed, dot the pan with just a hint of butter—you don't want to fry the crepe but don't want it to stick, either. Remember there is butter in the batter. Heat the pan over the stove at medium or medium-high heat. Adjust heat later accordingly.

Think "thin" when pouring the batter into the center of the pan. Cover about ⅓ of the pan's surface. With the handle of the pan, pick it up and use a swirling motion to cover the rest of the pan. Let the crepe lightly cook until the edges are lightly browned. Use a flat spatula and/or fingers to remove crepe from the pan and stack on a plate. If serving the crepe immediately, you do not have to cook both sides. If freezing for future use, flip the crepe over to lightly cook for a few seconds. This recipe makes about a dozen crepes.

When serving a crepe, fold it in half, and fold in half again, forming a triangle four layers thick. Add filling or a fruit or chocolate spread before folding. If choosing to serve without filling, a sprinkling of powdered sugar or a dusting of cocoa and fresh berries is wonderful. Make it a classic crêpe suzette topped with an orange buttery syrup, orange zest and a dash of Grand Marnier orange liqueur.

Rees Mansion B&B's Pie Crust

If you ever celebrated a holiday in the Rees Mansion's dining room or relaxed after dinner in the lounge with a cup of coffee or an after-dinner drink, you may have enjoyed a piece of pie. Traditional fruit and classic cream pies were served, especially during the holidays. The crust was tender, flaky and flavorful. After dinner one evening, I asked management for the crust recipe. It was a matter of "ask and you shall receive." The crust is easy to prepare.

In bowl, blend:
1 ⅓ cups shortening
3 cups flour
⅛ teaspoon salt
1 teaspoon sugar

Blend well with pastry cutter to a "cornmeal" consistency.

In a separate bowl:
1 egg
5 tablespoons water
3 tablespoons vinegar

Blend mixture and pour over flour-shortening mixture. Lightly mix. Place in refrigerator for at least 10 minutes. Lightly knead. Cut in two equal parts and roll out crusts. Bake according to the pie recipe. Makes two 8-9" crusts.

Left Bank Coffee Toffee Pie

The Left Bank had classic French desserts like crème brûlée, chocolate mousse and, sometimes, luscious, rich pies. Enjoy this popular dessert from the Left Bank, courtesy of Nadean Pulfer.

Crust:
1 ½ cups flour
1 ounce unsweetened chocolate
¼ cup brown sugar
6 tablespoons butter
¾ cup chopped pecans
1 teaspoon vanilla
1 tablespoon water (or coffee)

Combine all ingredients well and place into 1 spring-form 10" pan. Pat down and press firmly. Prick crust with fork. Bake for 350 degrees for 15 minutes. Cool.

Filling:
¾ cup butter
1 cup sugar
1 ½ ounces of unsweetened chocolate, melted
3 eggs
1 tablespoon instant coffee dissolved in small amount of brewed coffee or water

Cream butter and sugar together until light and fluffy. Add melted chocolate and coffee. Beat in eggs one at a time. Pour filling onto crust in spring-form pan. Chill well.

Topping:
2 cups whipping cream
½ cup powdered sugar
2 tablespoons instant coffee
2 tablespoons Kahlua coffee liqueur

Whip cream and add the sugar, instant coffee and Kahlua. Continue to whisk until soft peaks form. Spread over pie. Chill for several hours. Double the recipe for three 8-9" pies.

Bibliography

Bentley, Judy. *Walking Washington's History: Ten Cities*. Seattle: University of Washington Press, 2016.

Bygone Walla Walla—Vintage Images of the City & County collected by Joe Drazan. http://wallawalladrazanphotos.blogspot.com.

Hart, Ted. *Walla Walla Residents and Business Registration*. Walla Walla, WA: Any-All Printers, 1970–73.

"History of Walla Walla." Walla Walla County Official County Government Site, 2012. http://www.co.walla-walla.wa.us/history.shtml.

Lyman, William Denison. *Lyman's History of Old Walla Walla County: Embracing Walla Walla*. Vol. 1. San Francisco, CA: W.H. Lever, 1852–1920.

McIntyre Walker, Catie. *Wines of Walla Walla Valley: A Deep-Rooted History*. The History Press, 2014.

Miller, D. Allen. *Eastern Washington Directory*. N.p.: Harris the Printer, 1883.

———. *Walla Walla Country Directory*. N.p.: Harris the Printer, 1881.

Moore, Stephen T. *Bootleggers and Borders: The Paradox of Prohibition on a Canada-U.S. Borderland*. Lincoln: University of Nebraska Press, 2014.

Perdue, Andy. "Washington Wine Industry Continues Incredible Growth" Great Northwest Wine. http://www.greatnorthwestwine.com/2015/09/14/washington-wine-industry-continues-incredible-growth.

Polk, R.L., Walla Walla Polk's City and County Directory. R.L. Polk, Inc. Seattle, 1922–24.

Salas, Elizabeth. "Mexican American Women in Washington." http://www.historylink.org/File/5629.

Smith, V. *Walla Walla City Directory*. N.p.: V. Amp. Smith, 1889.

Walla Walla 2020. http://ww2020.net.

Walla Walla Union-Bulletin Archives. 1945–95. https://wallawallaunionbulletin.newspaperarchive.com.

Index

About the Author

Catie McIntyre Walker in front of Passatempo Taverna, former home of the Pastime Café. *Photo by Dee Cusick, Walla Walla.*

Catie McIntyre Walker was born, raised and has lived most of her life in Walla Walla, Washington. She's worn many crowns through her lifetime—a few crowns made of roses, and even a few crowns made of rose thorns. She's worn the following crowns: daughter, sister, student, administrative assistant for funeral homes and law firms, community volunteer, shop owner, crafter, collector of old treasures, recipe queen, dog lover, blogger, writer and author.

The last three crowns—blogger, writer and author—have been rather serendipitous and have taken Catie on an incredible journey. In 2005, she became one of the original wine bloggers in Washington State, known as the Wild Walla Walla Wine Woman. She is a graduate of the Institute for Enology and Viticulture at Walla Walla and has been a wine judge for various competitions in the Northwest. She has been a guest speaker, instructor and participant on panels regarding social media for wine writers and wineries.

Catie is also a freelance writer and has written for *Walla Walla Lifestyles* magazine (*Walla Walla Union-Bulletin*) and various other Northwest lifestyle and wine publications. She is the author of *Wines of Walla Walla Valley: A Deep-Rooted History* (The History Press). In her spare time, Catie can be found blogging at passementaries.blogspot.com and catiemcintyre.com, as well as writing "cozy" mystery stories for future publishing.